Speed Kings

Racing Photography by Dirk Behlau

Die Gestalten Verlag

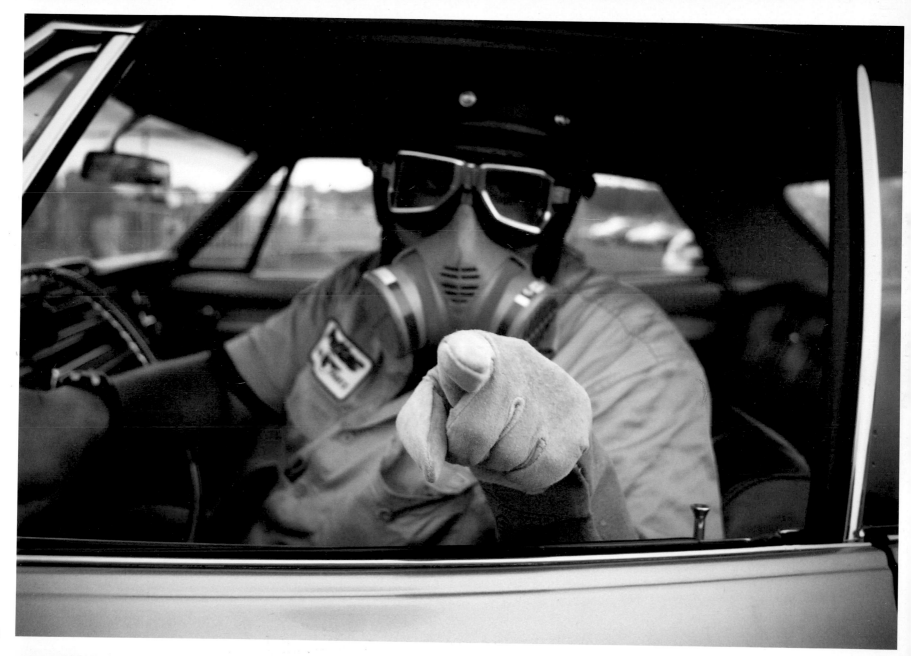

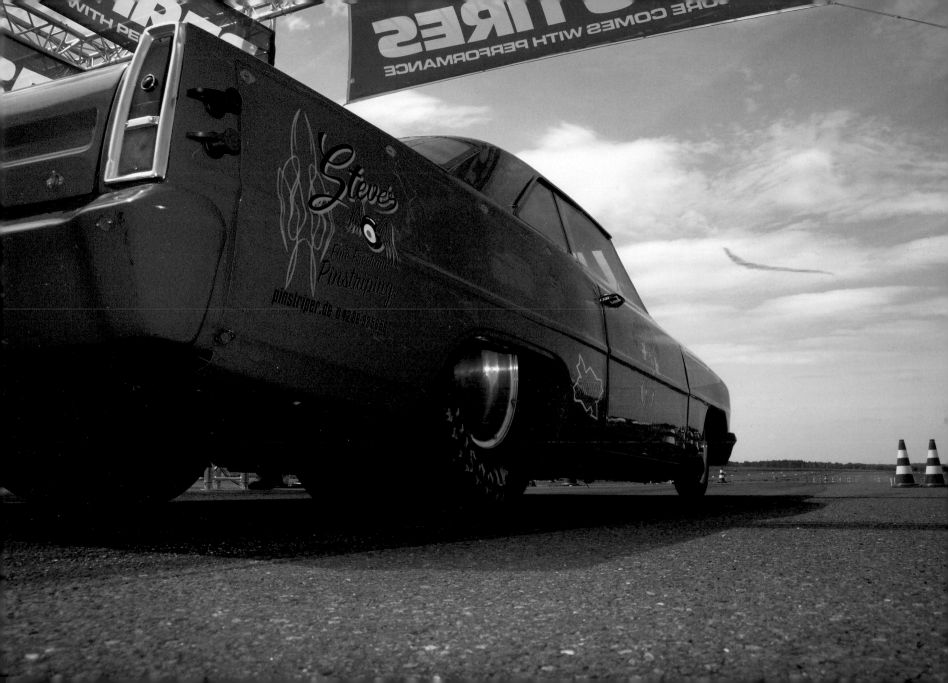

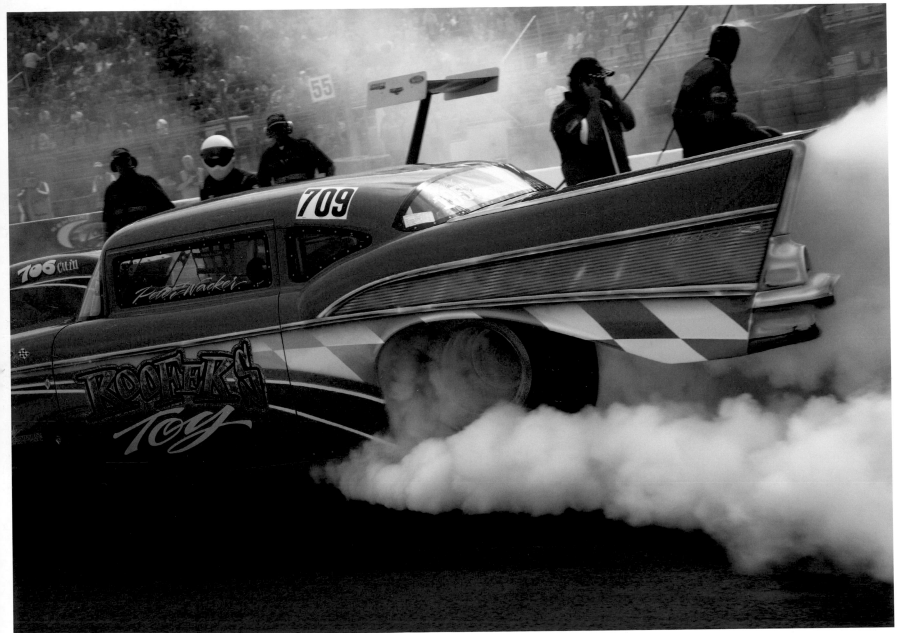

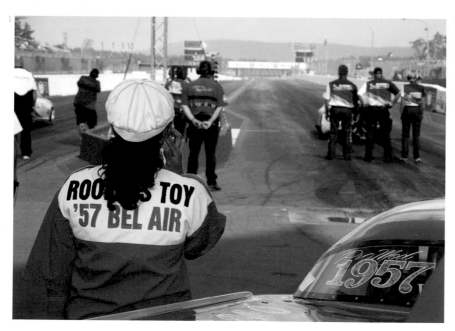

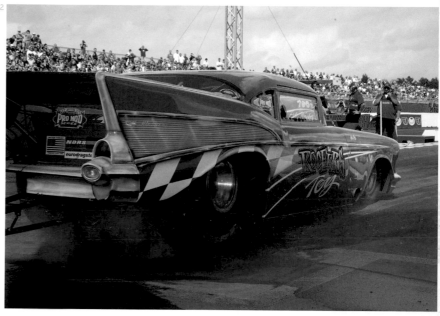

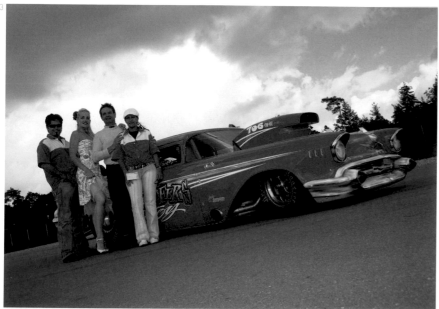

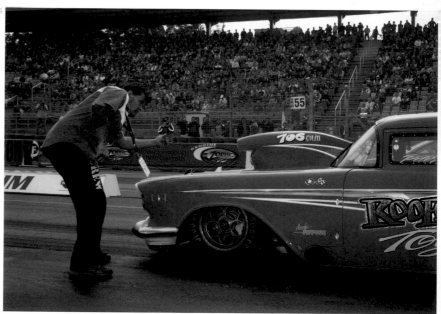

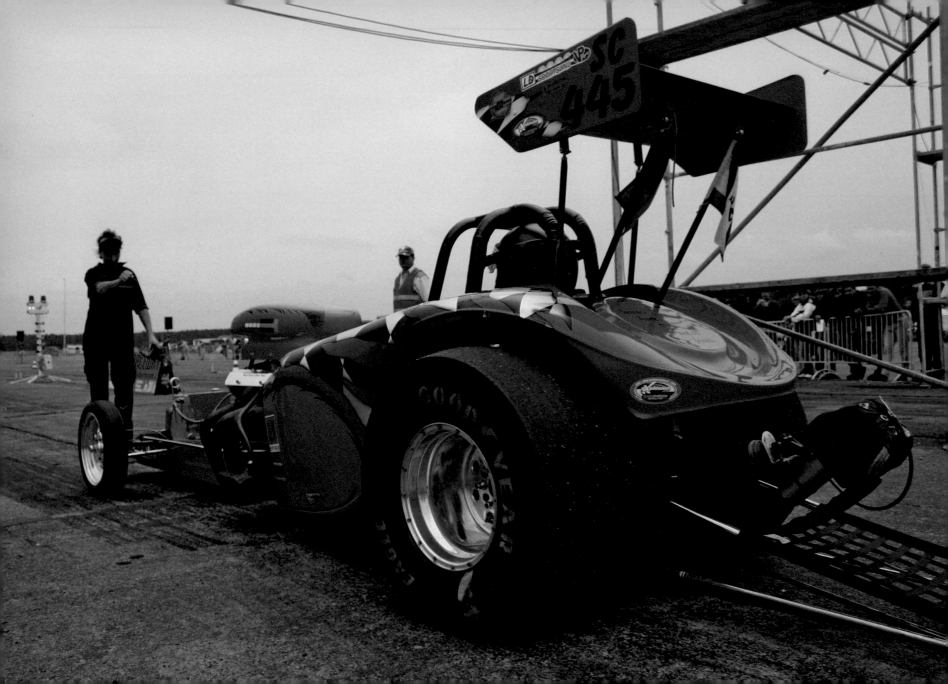

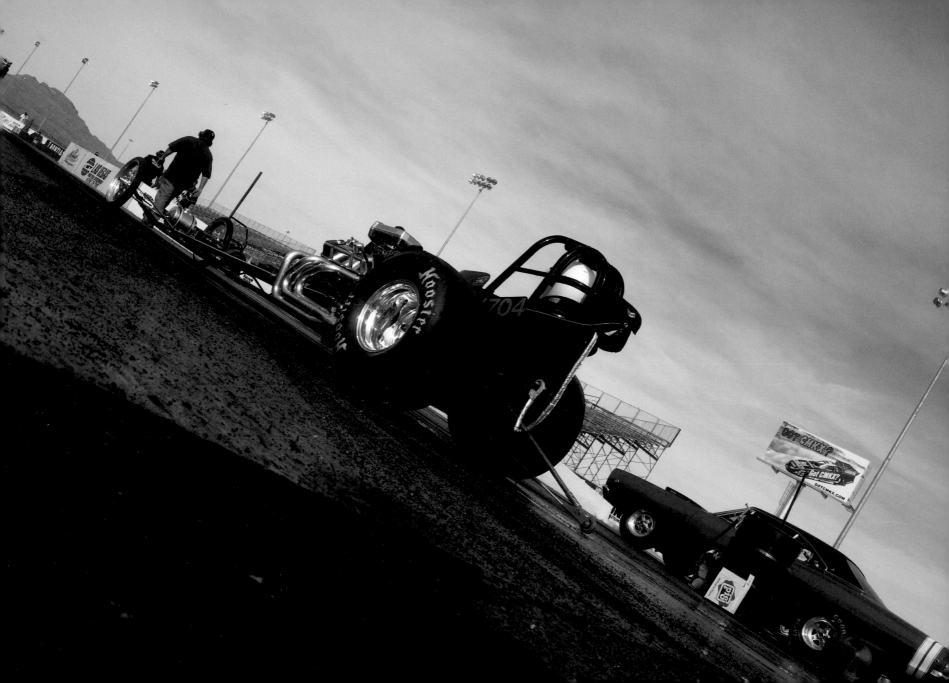

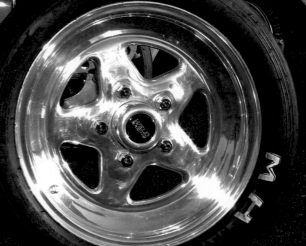
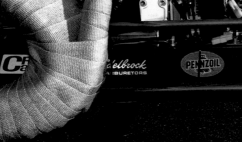

SC/
#409
DRIVER: JULIAN ROSE

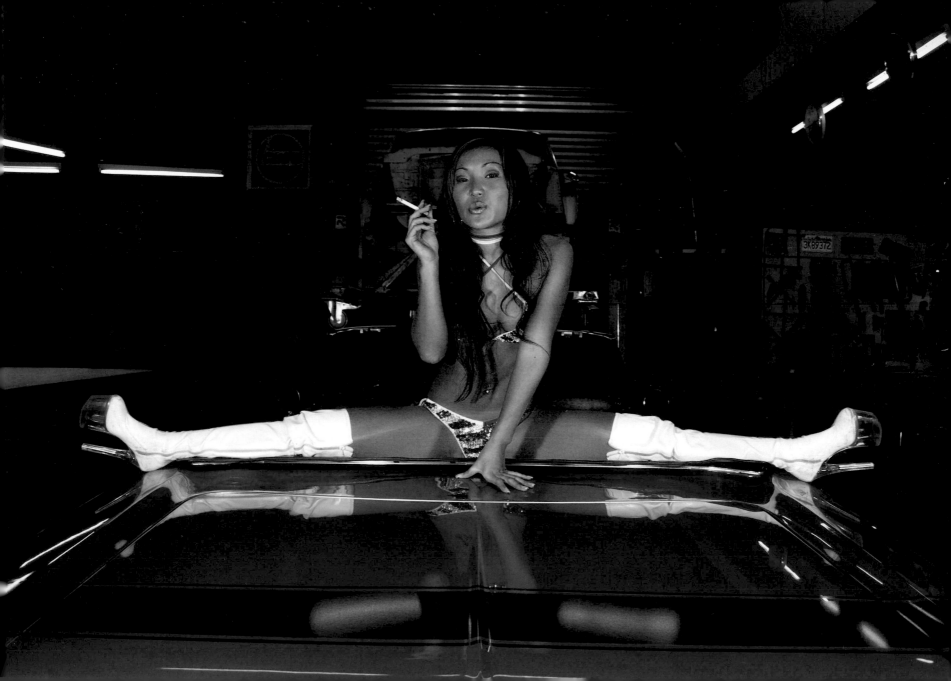

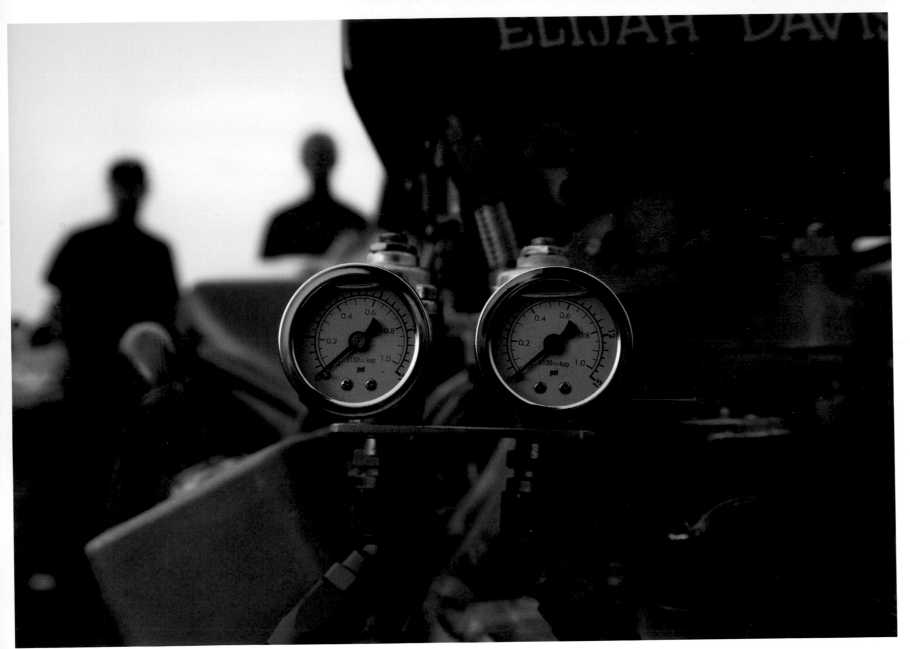

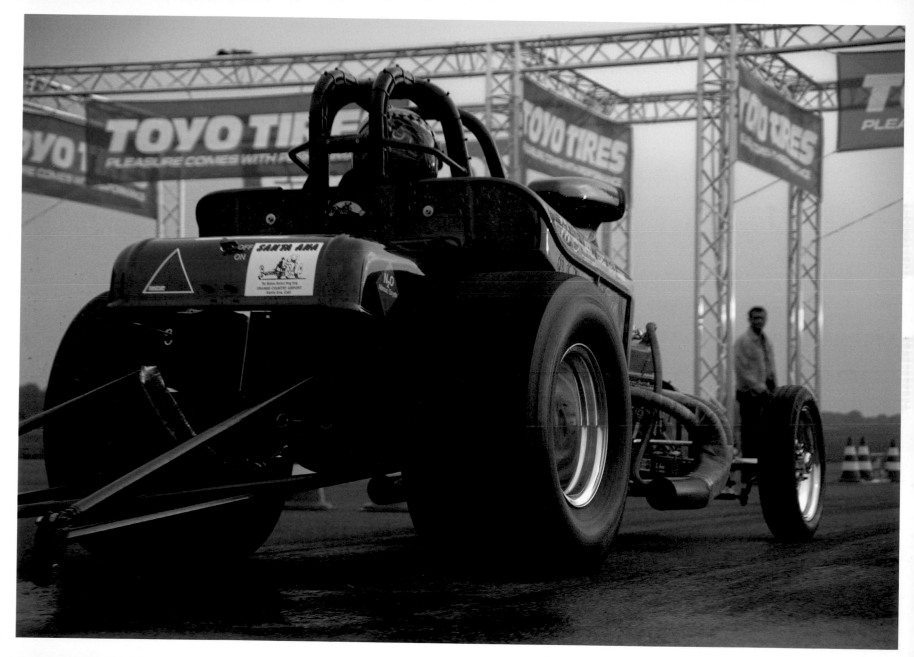

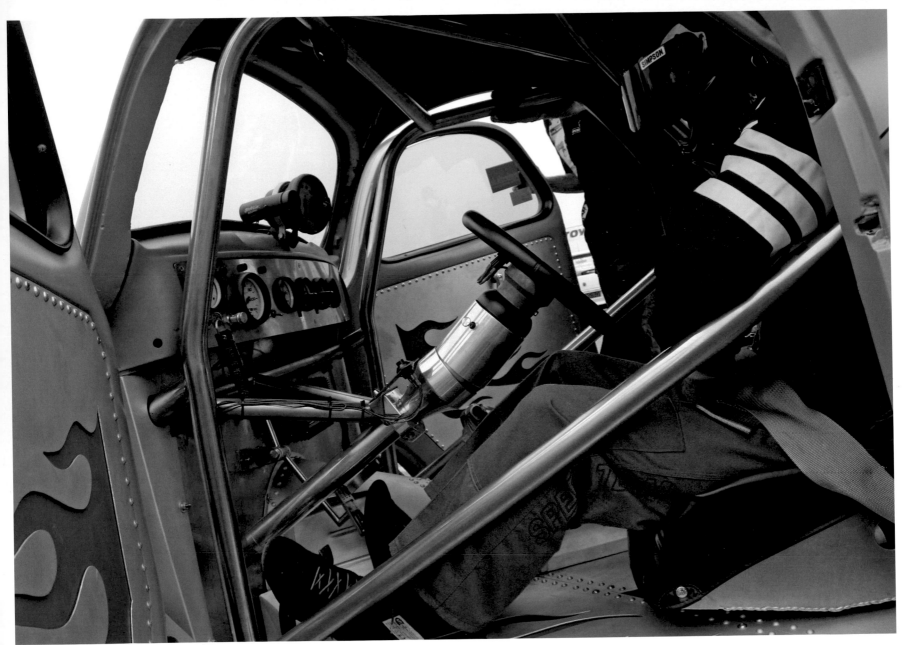

14

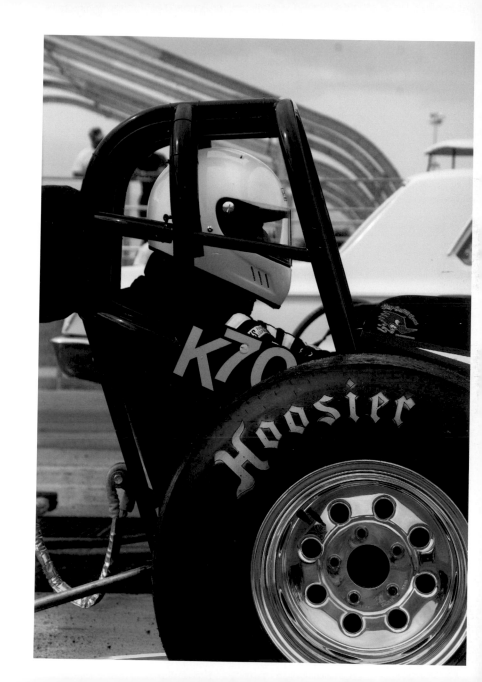

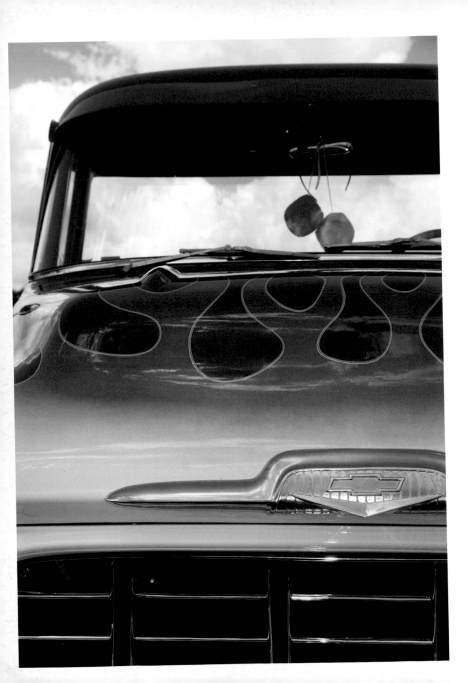

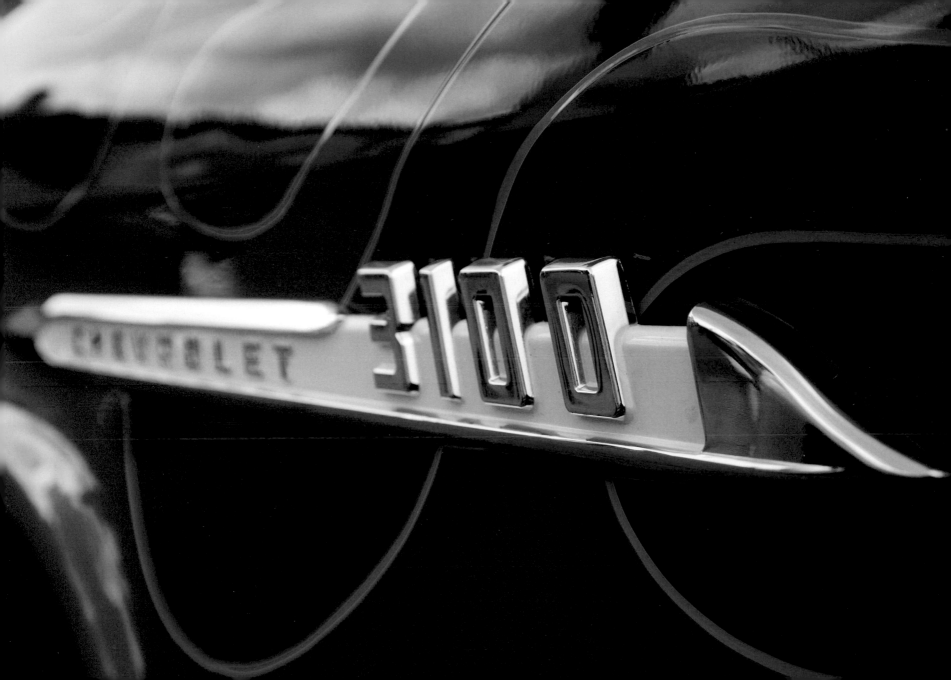

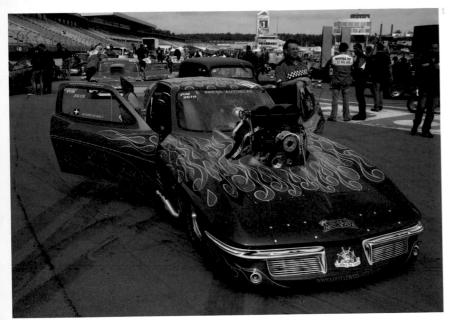

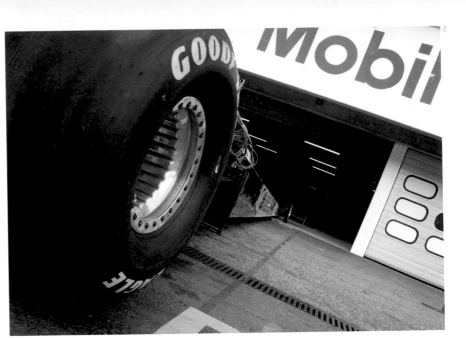

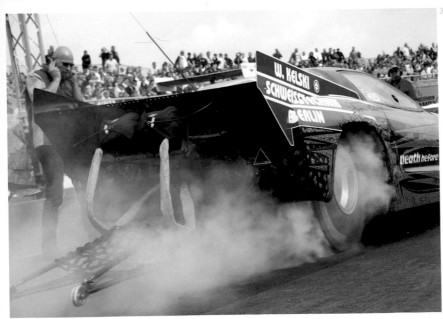

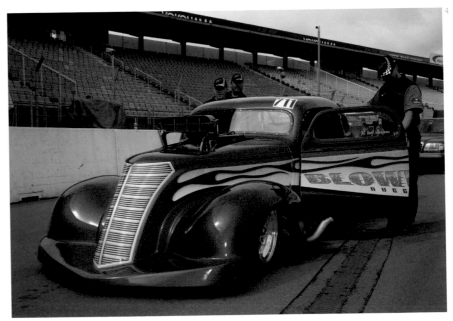

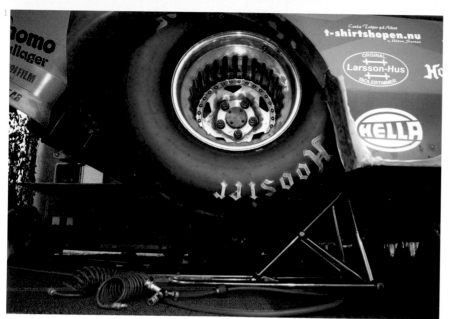

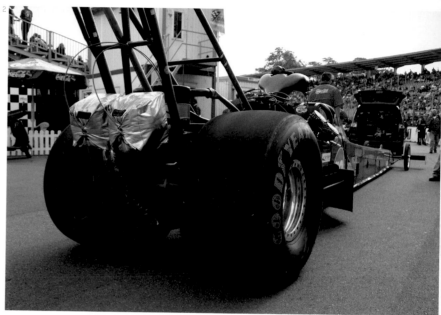

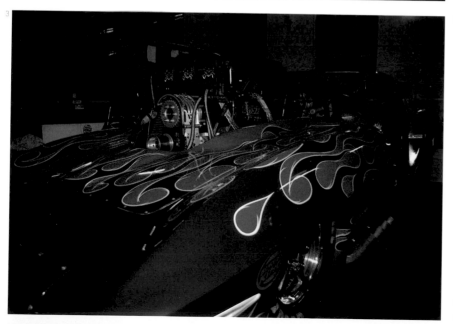

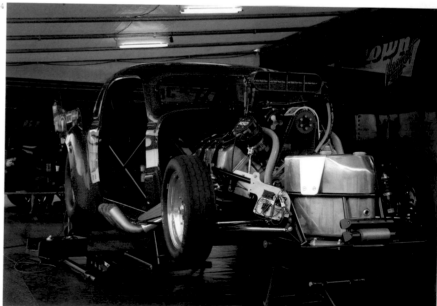

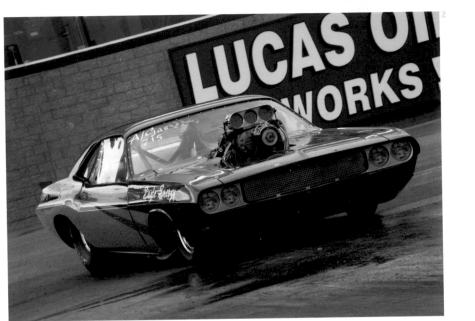

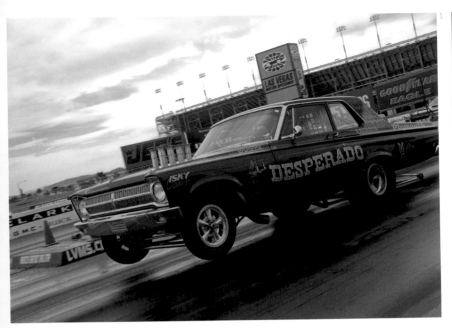

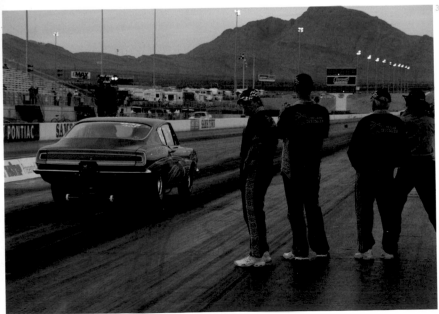

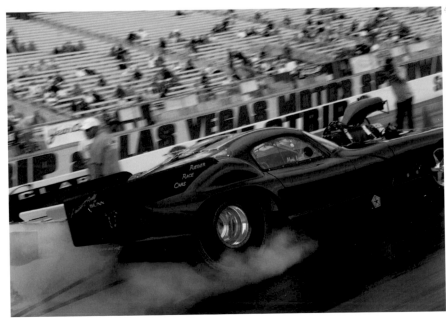

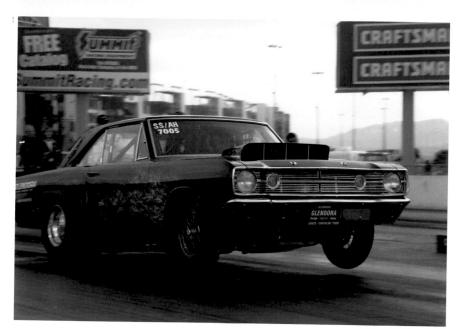

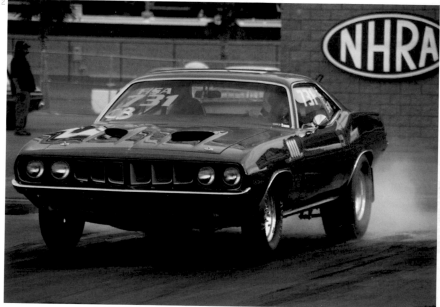

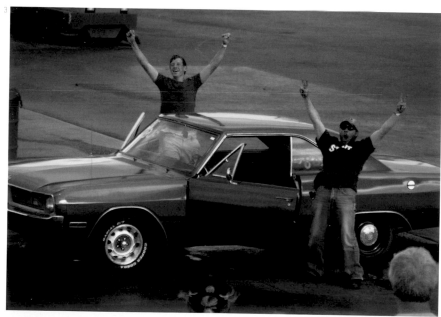

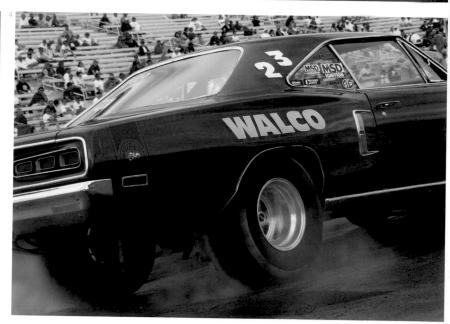

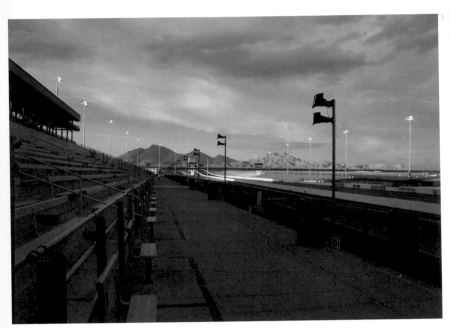

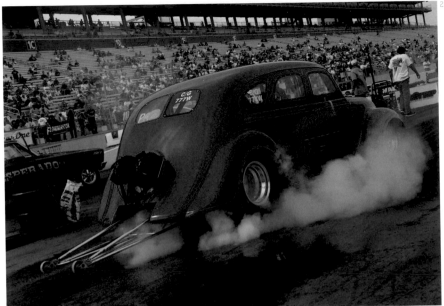

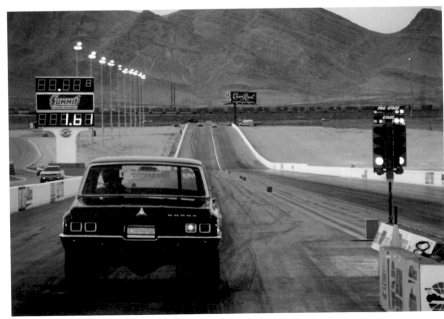

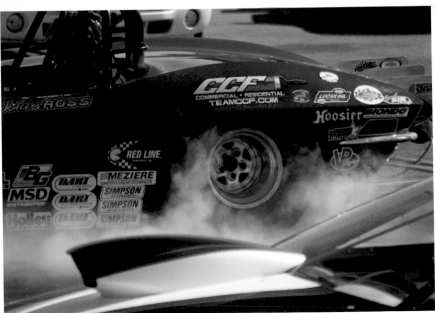

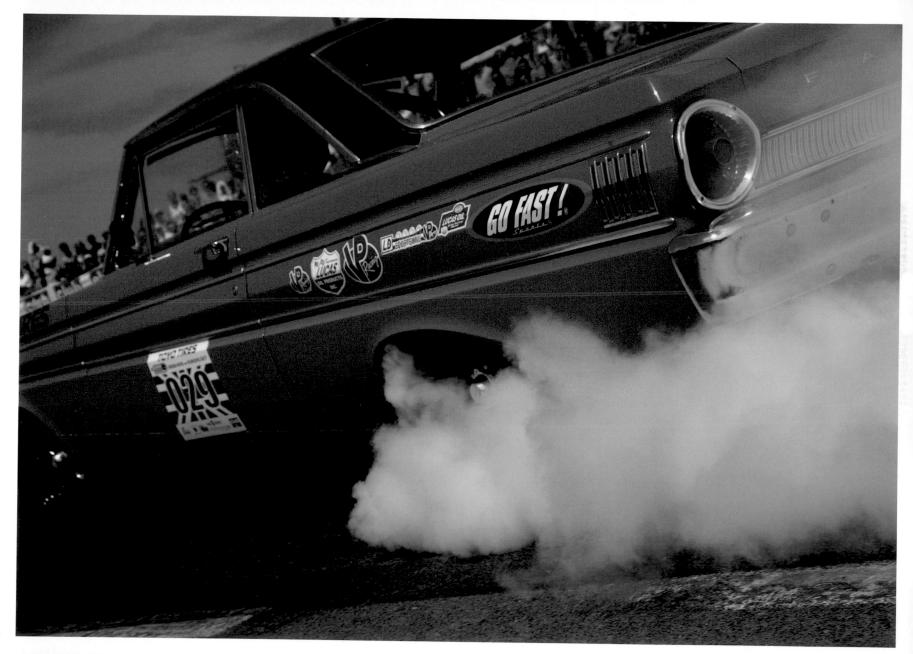

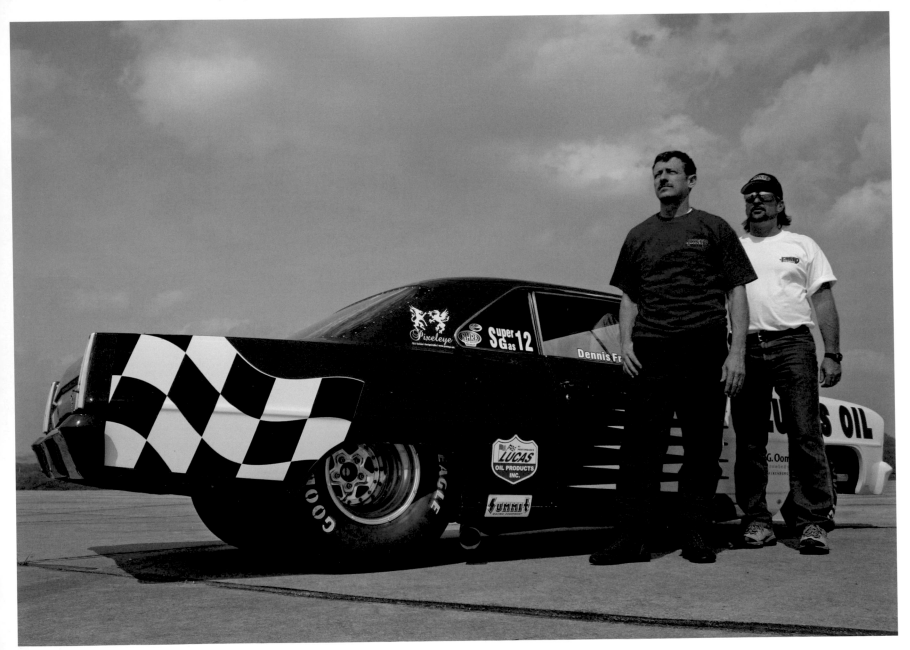

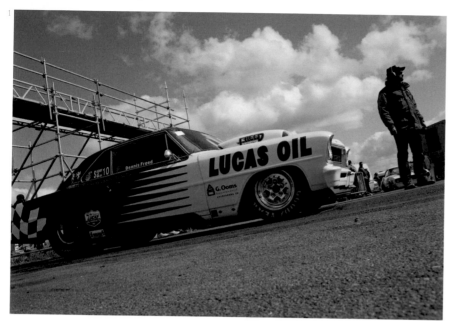

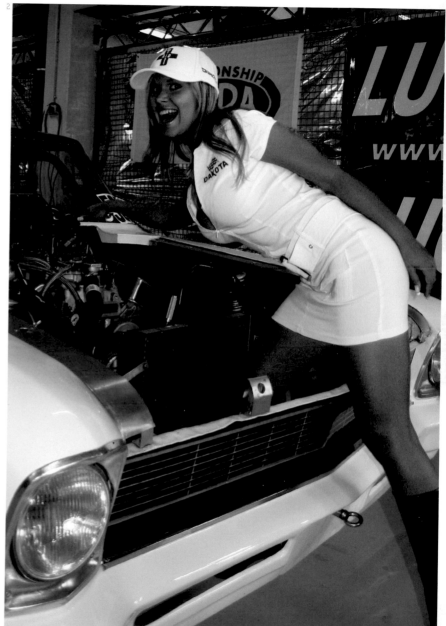

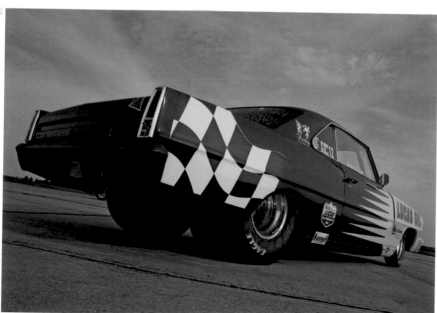

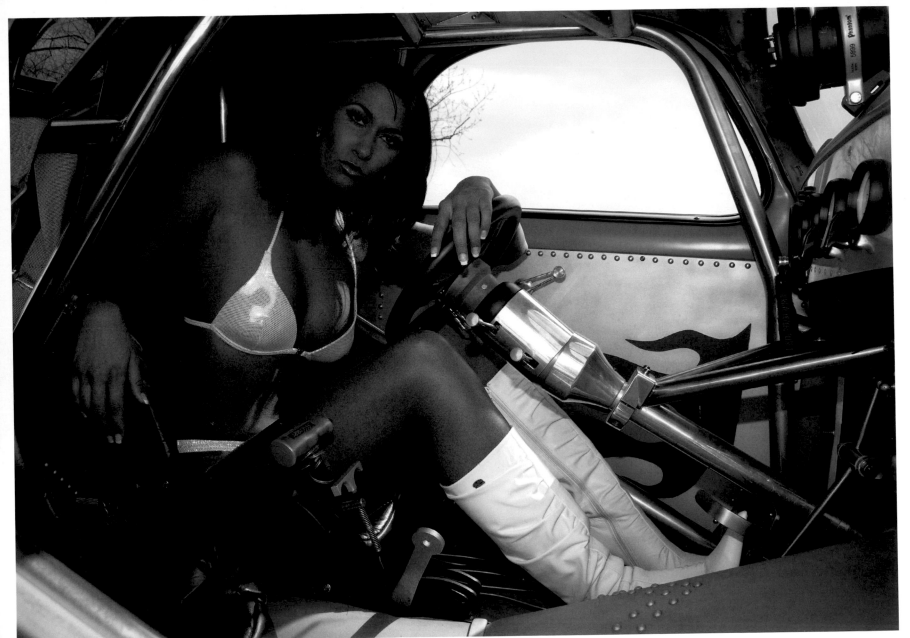

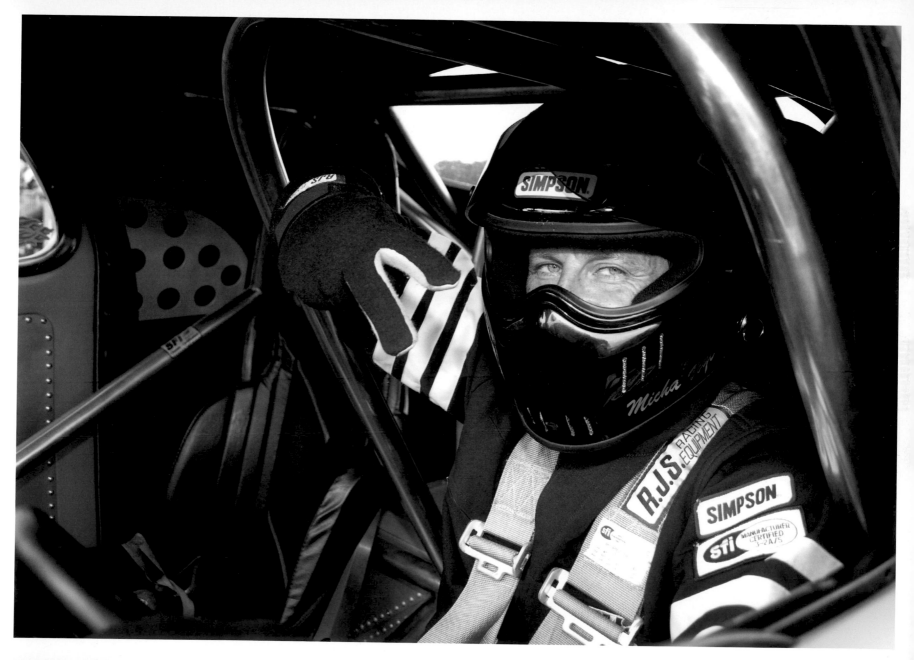

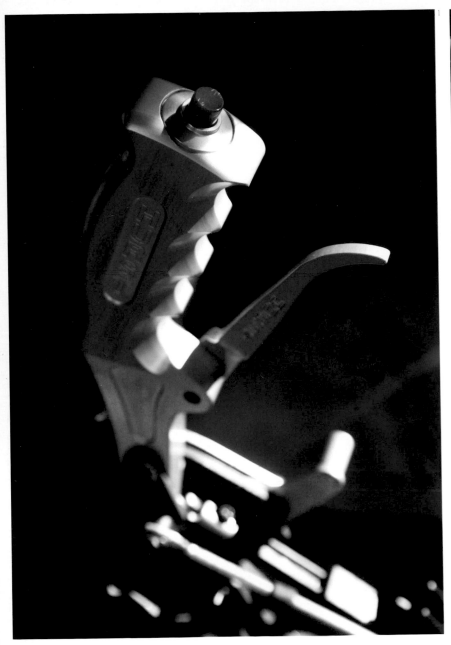

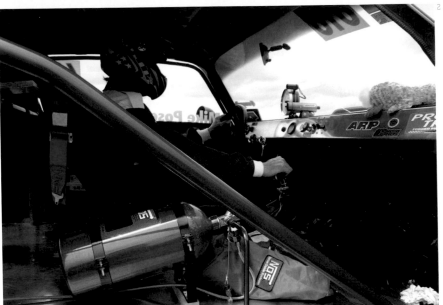

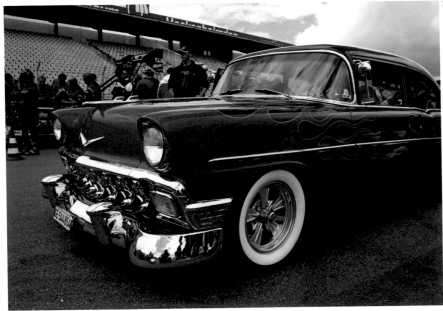

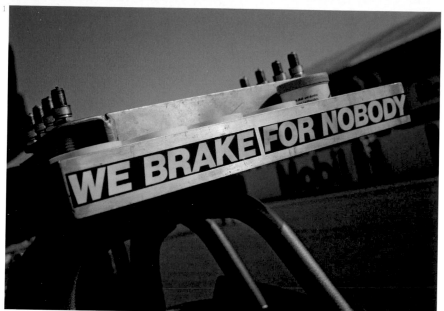

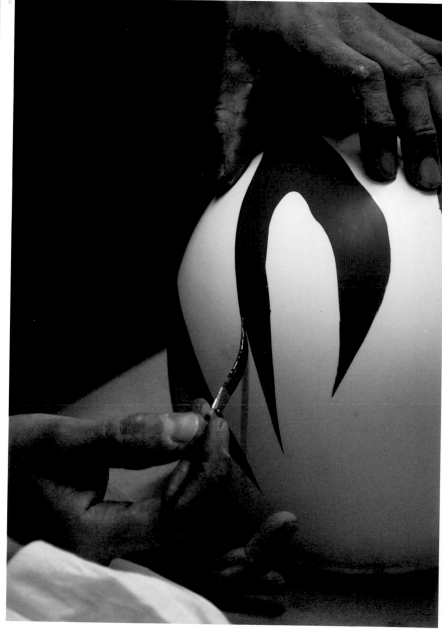

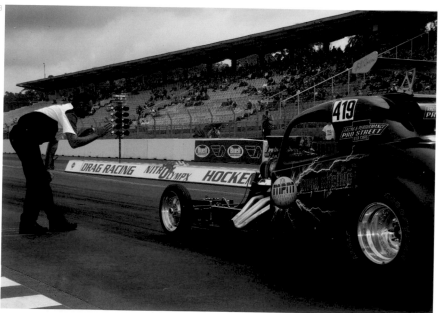

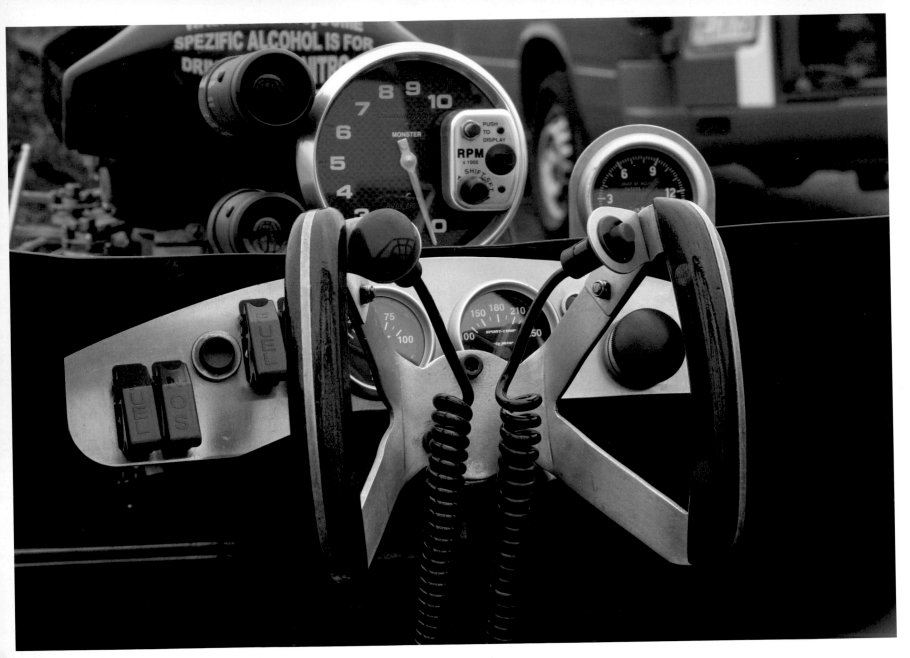

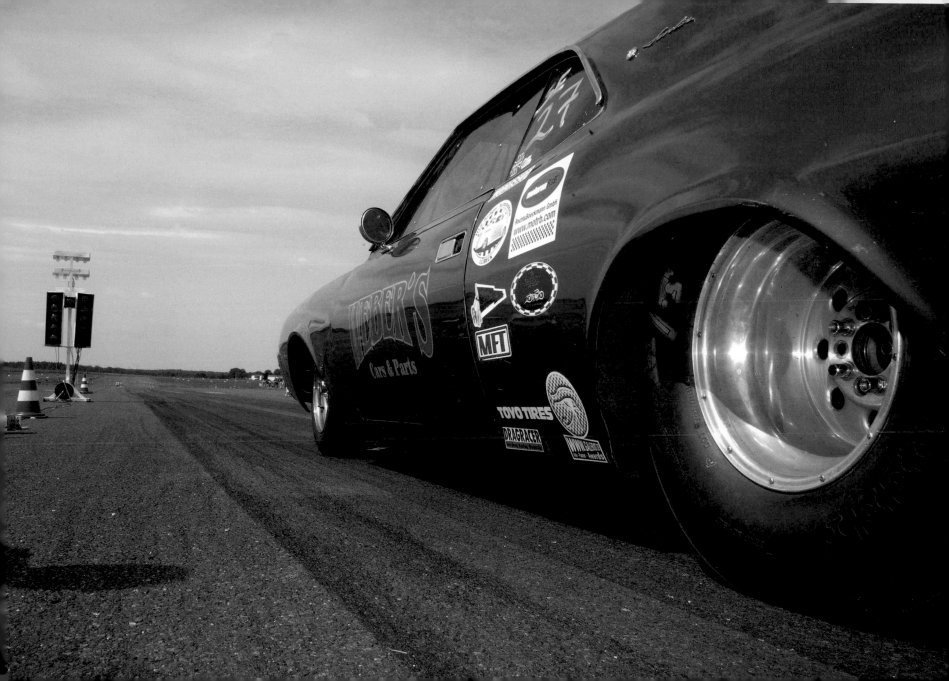

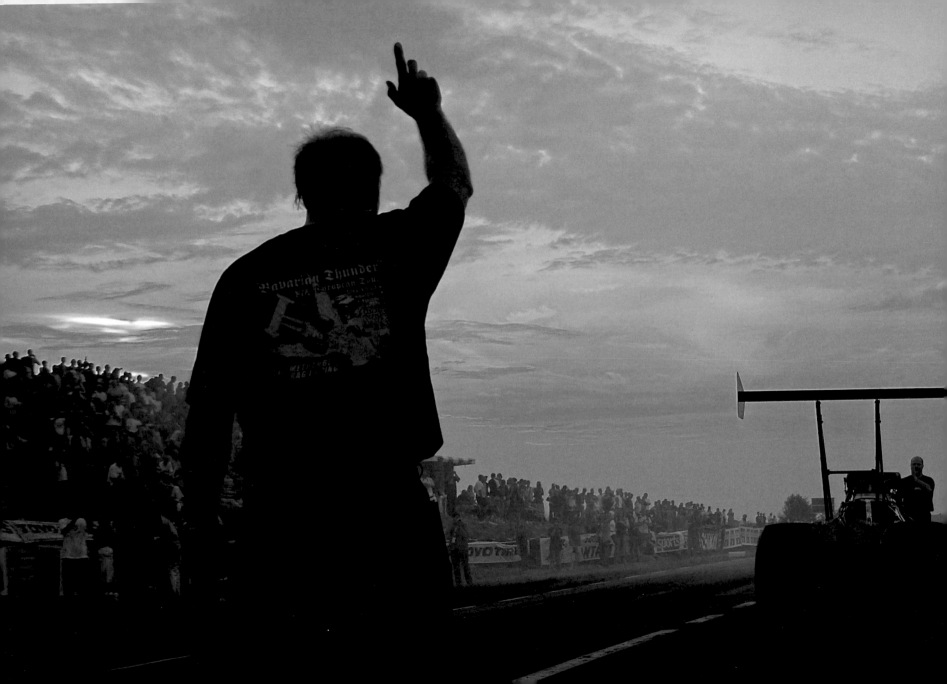

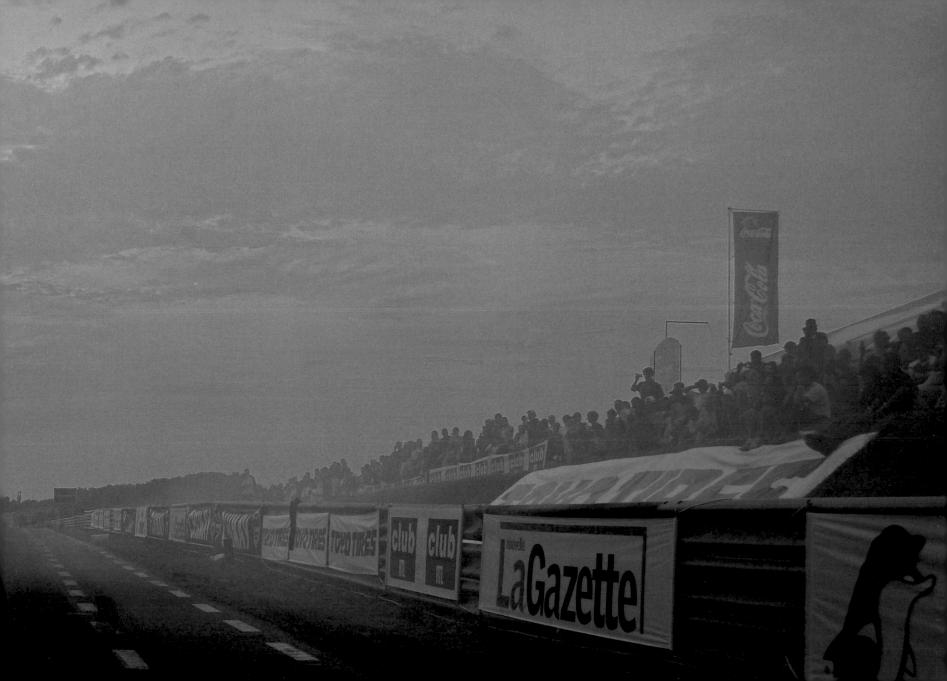

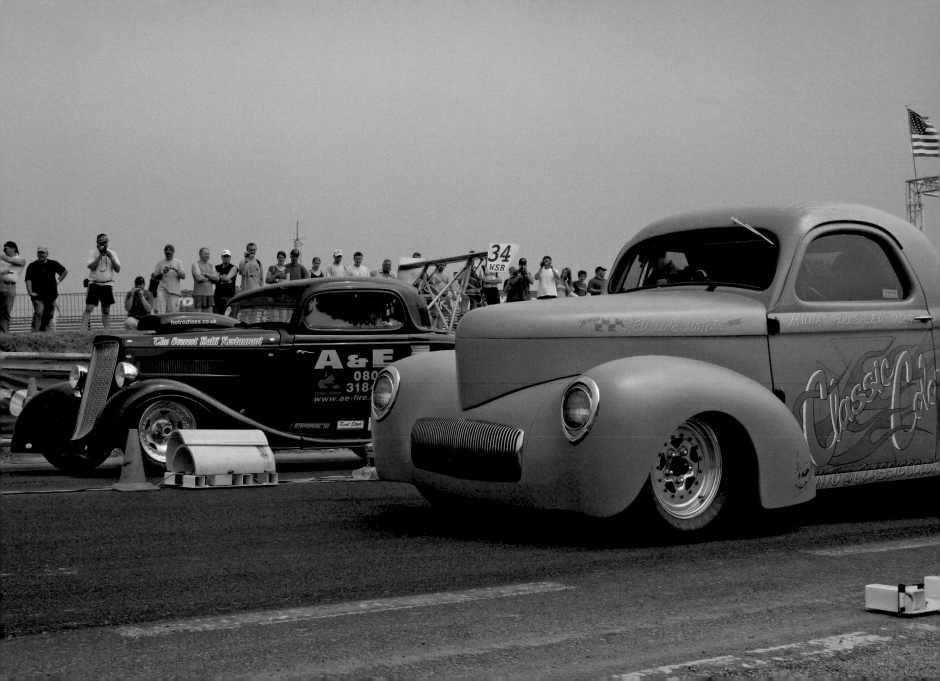

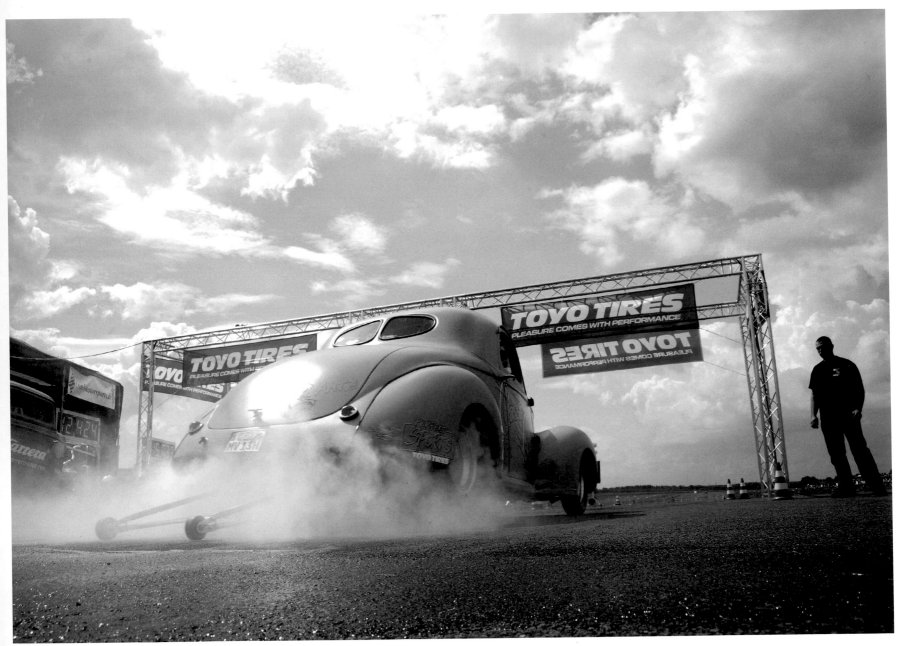

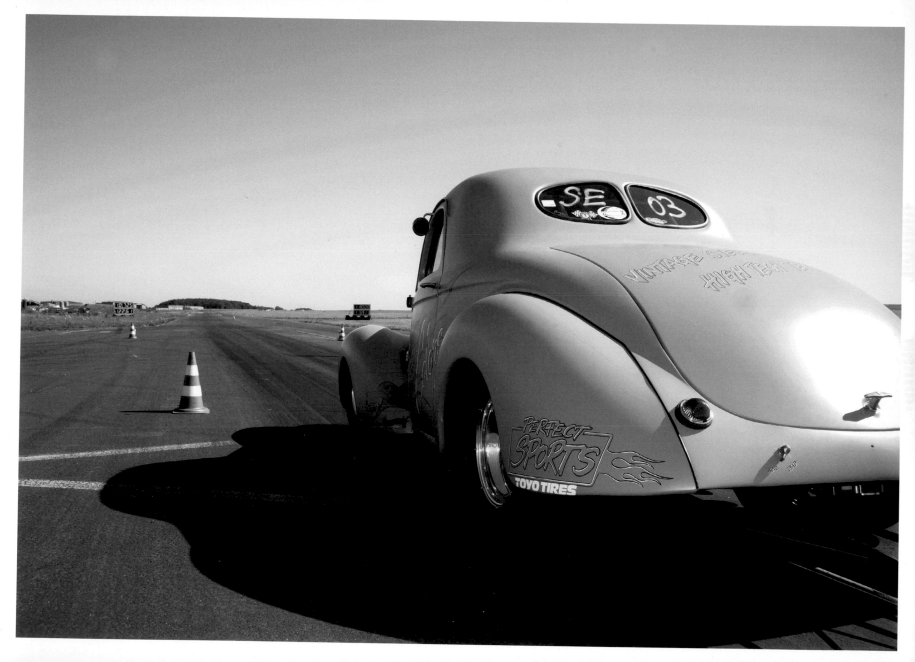

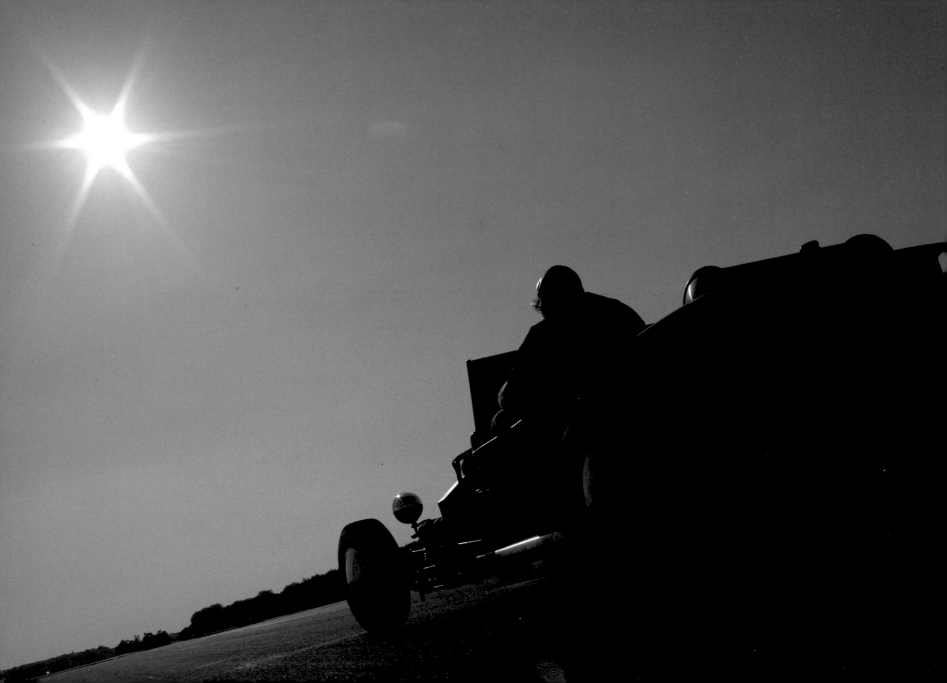

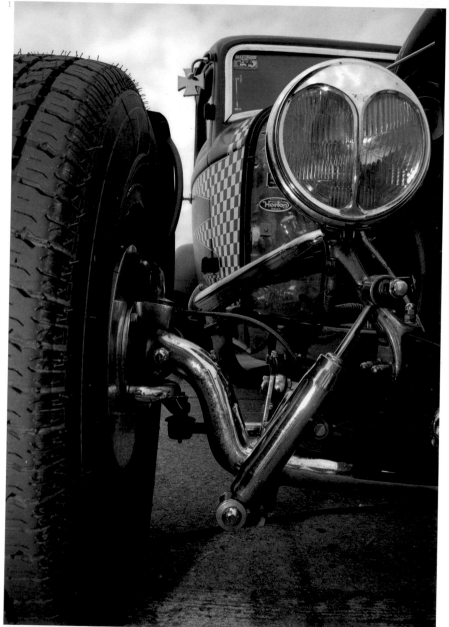

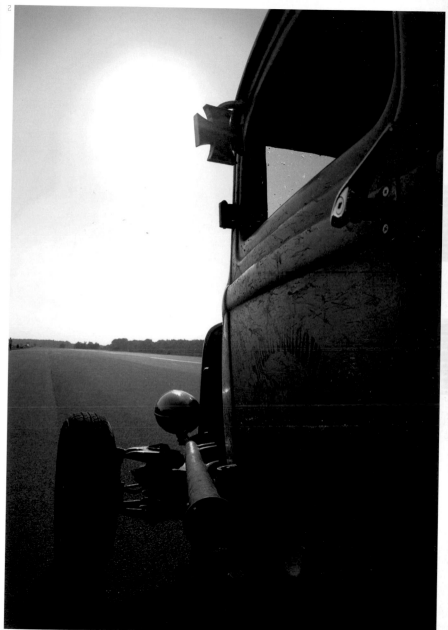

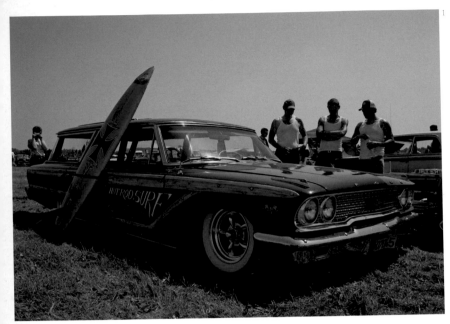

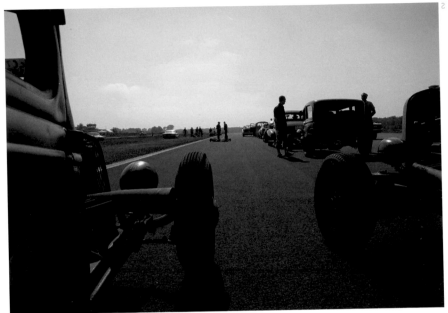

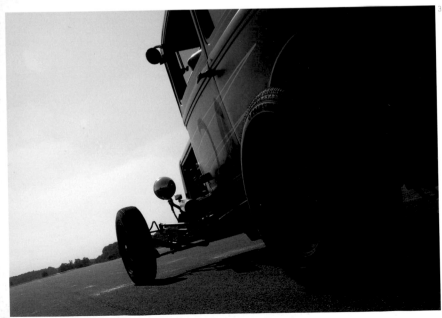

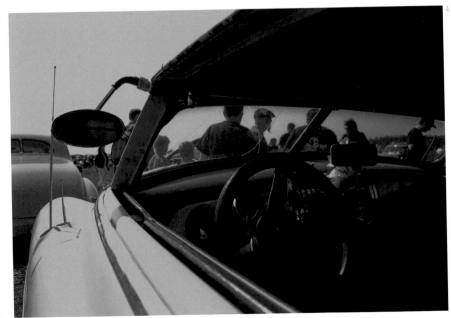

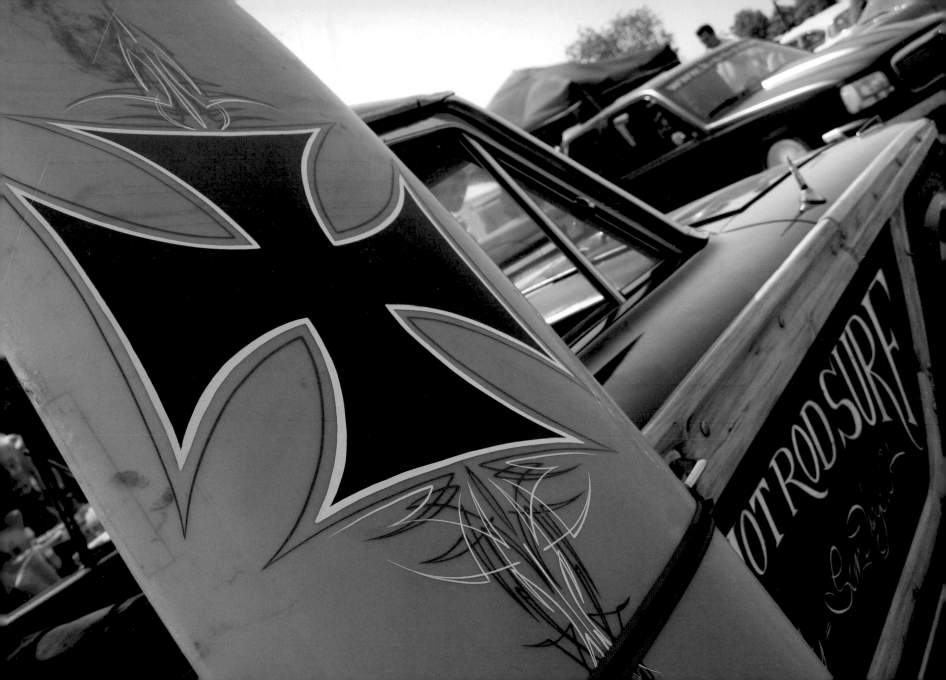

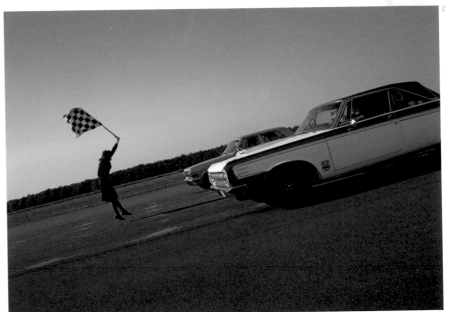

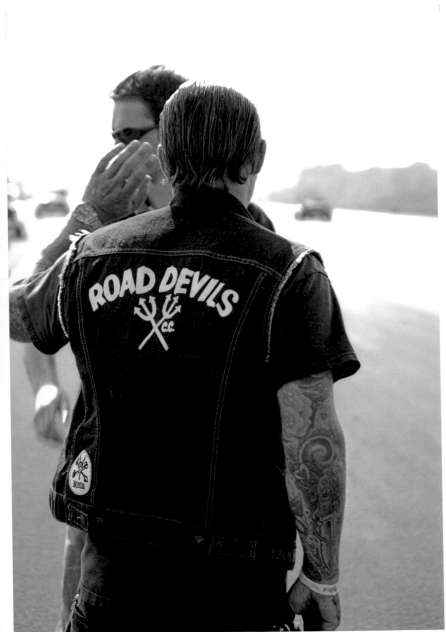

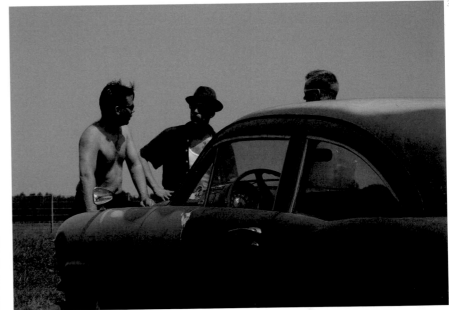

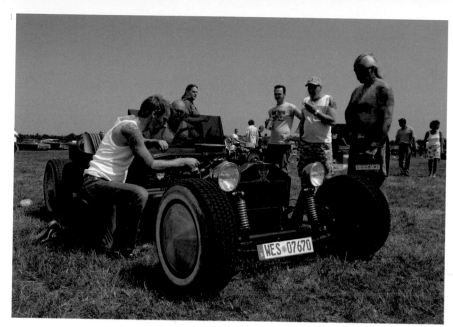

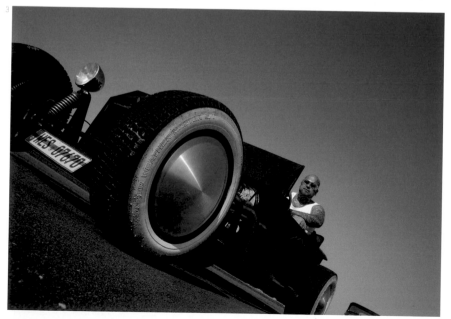

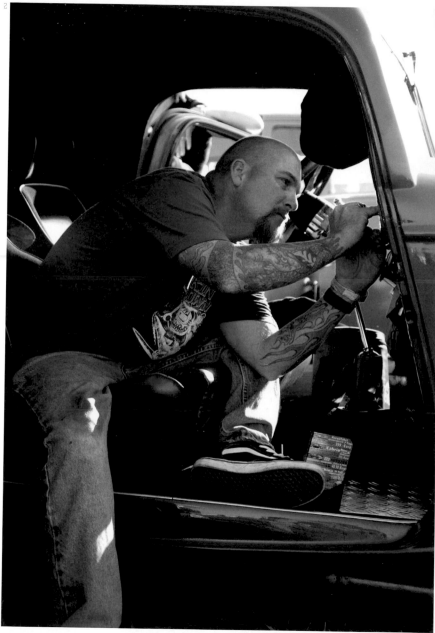

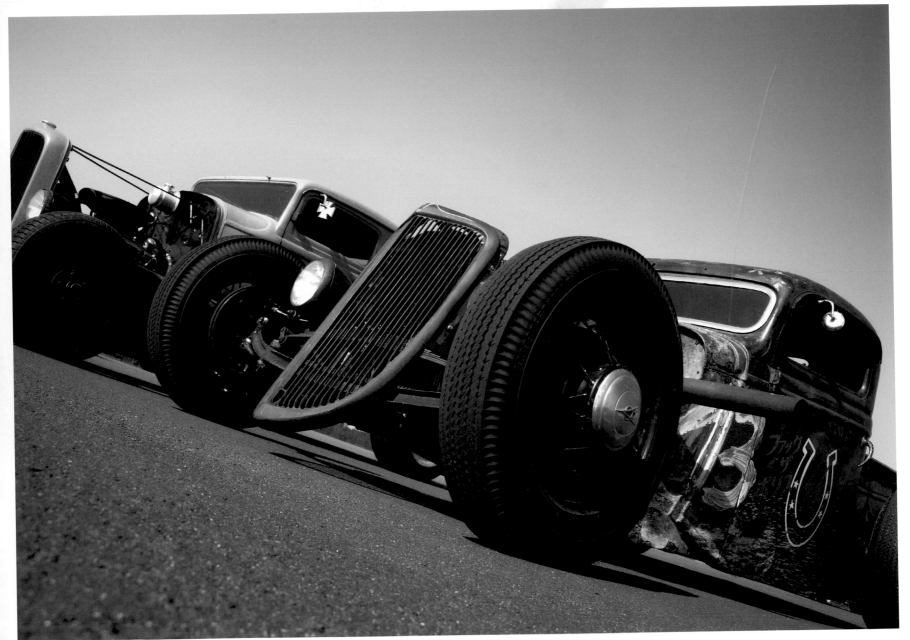

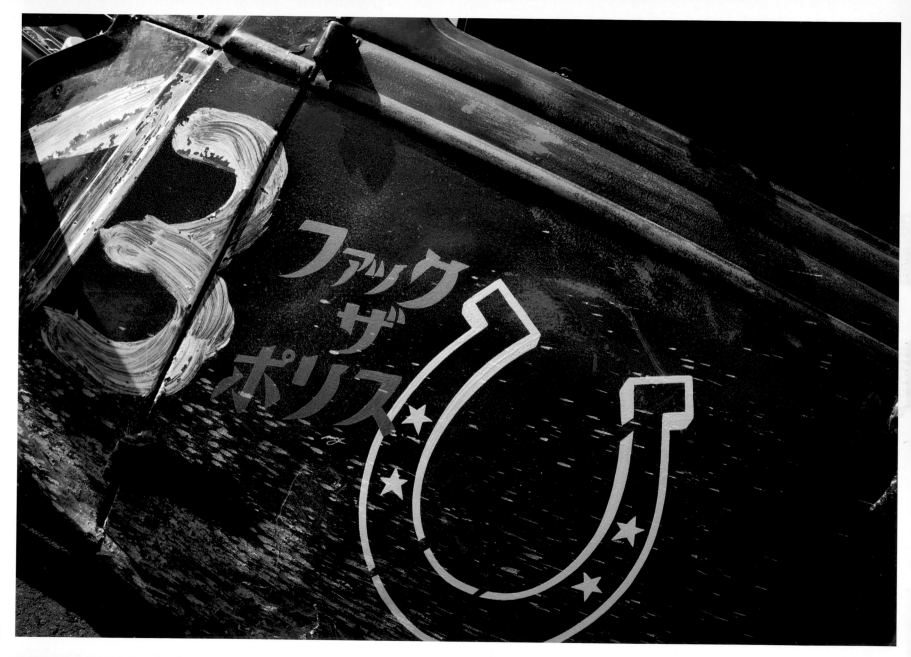

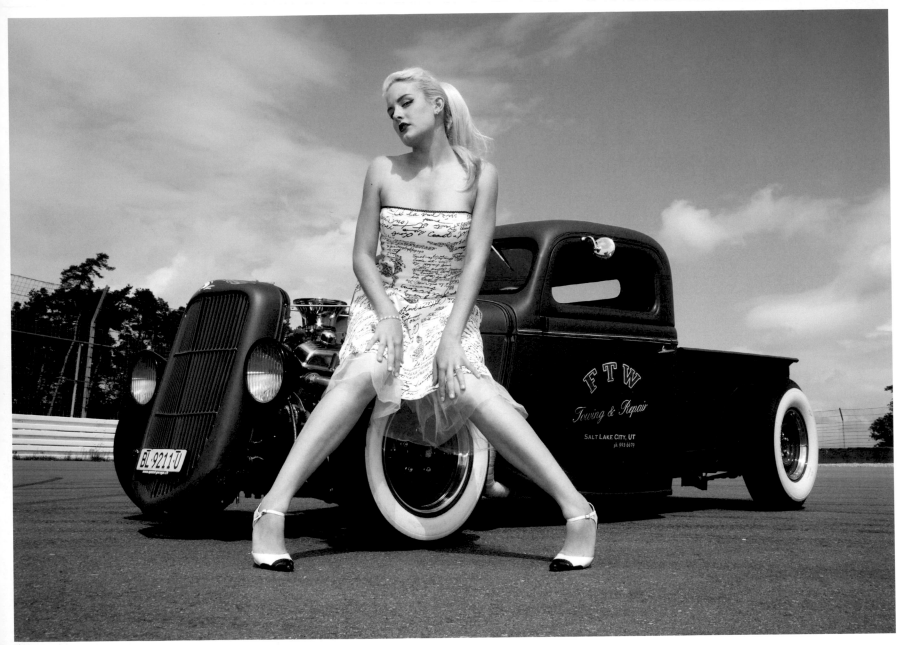

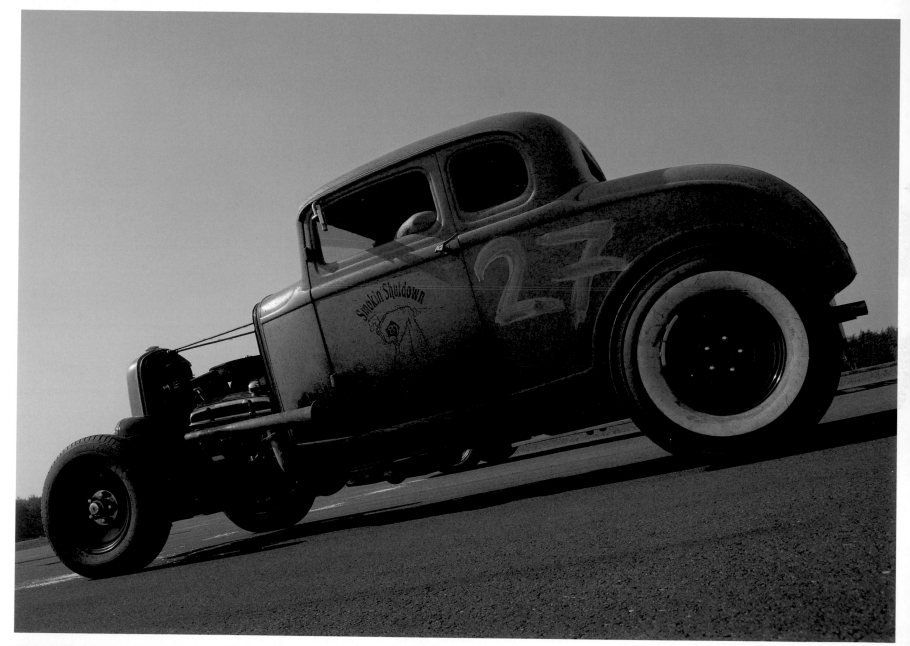

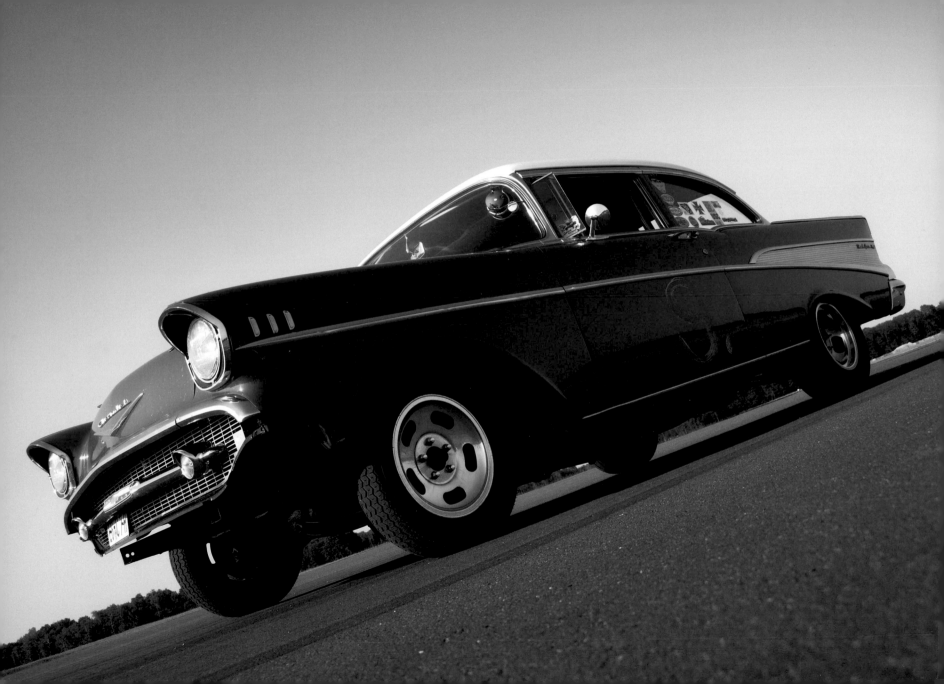

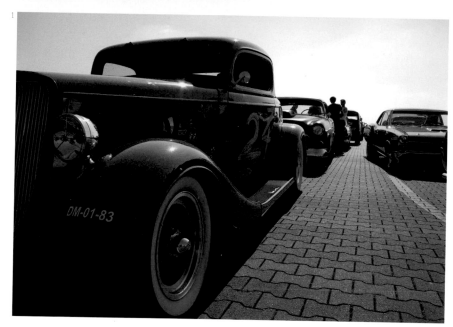

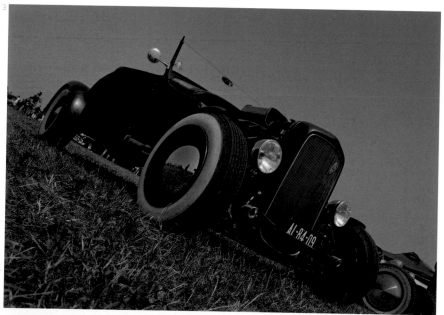

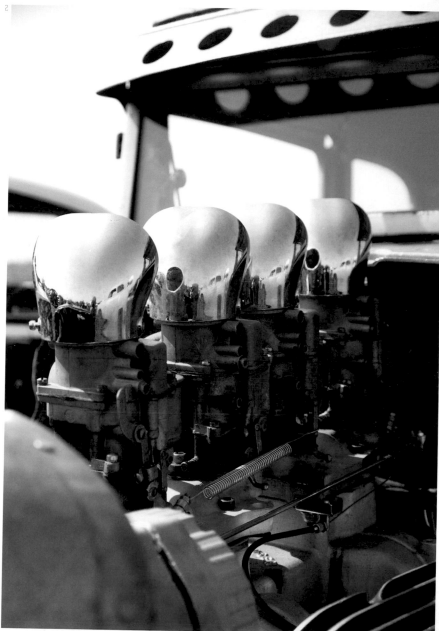

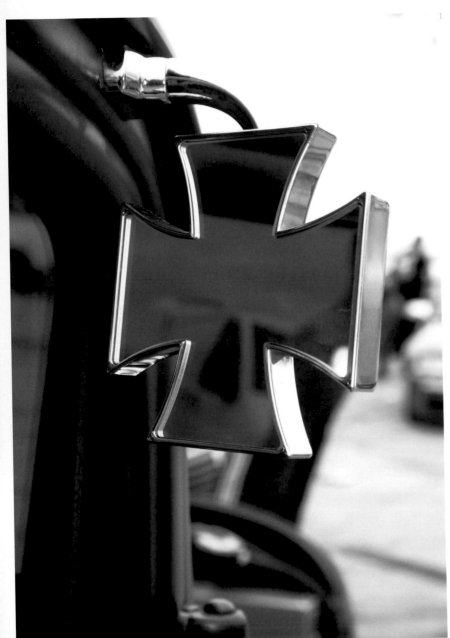

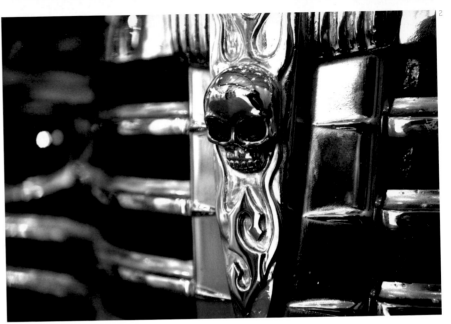

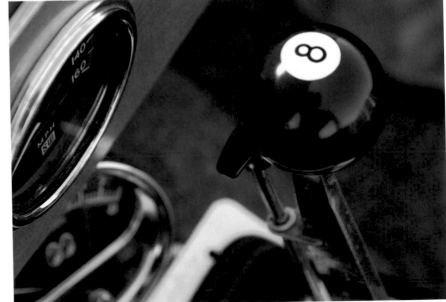

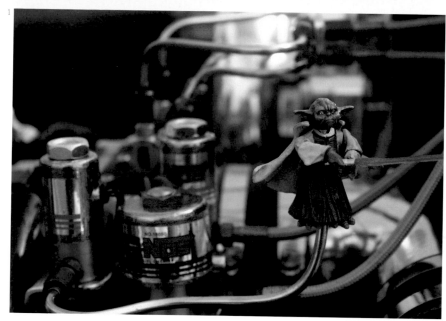

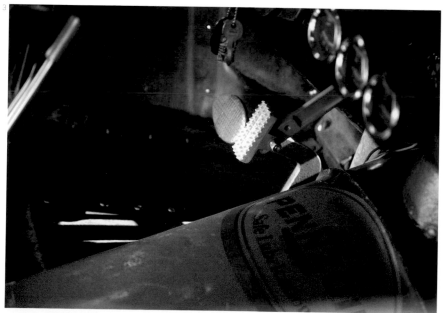

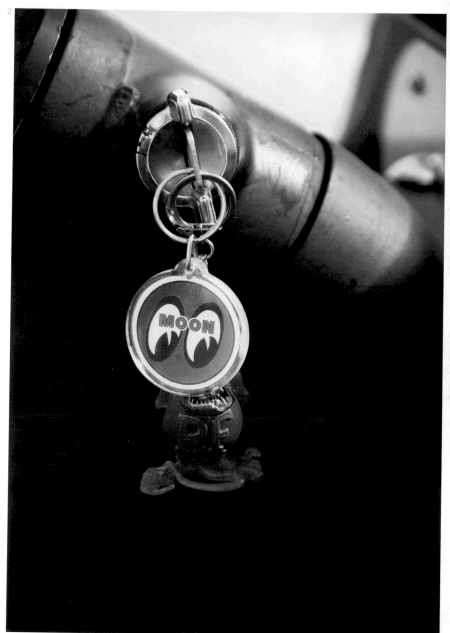

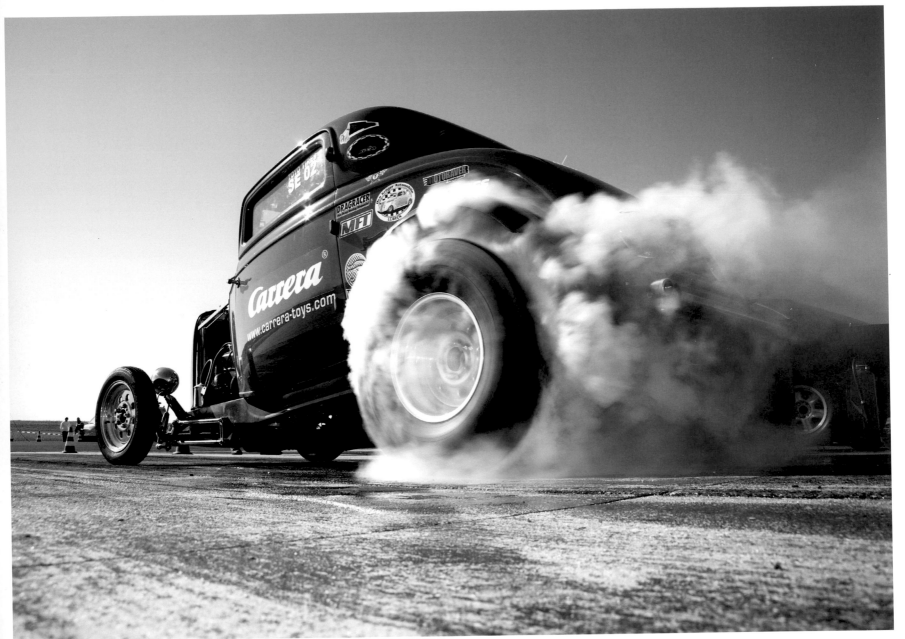

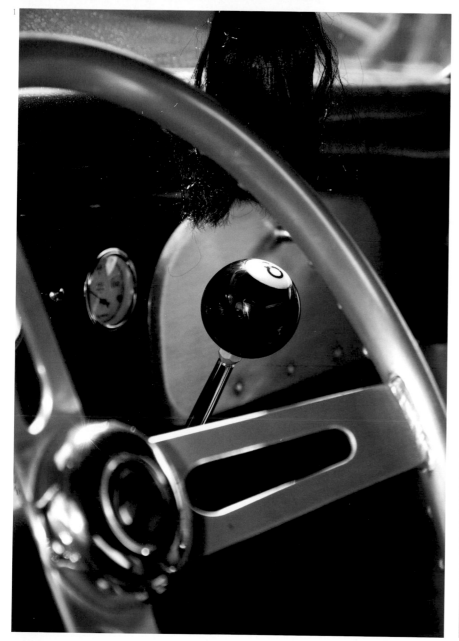

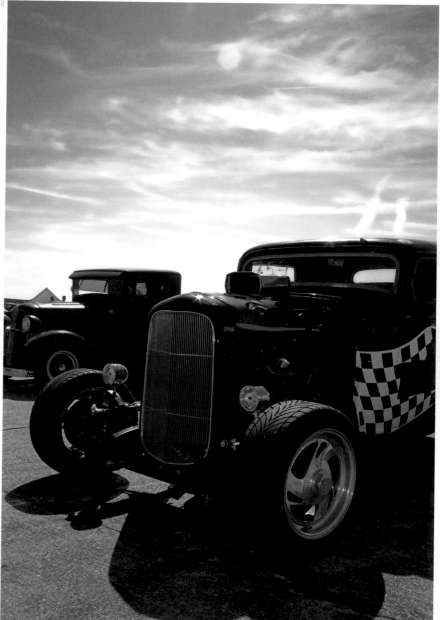

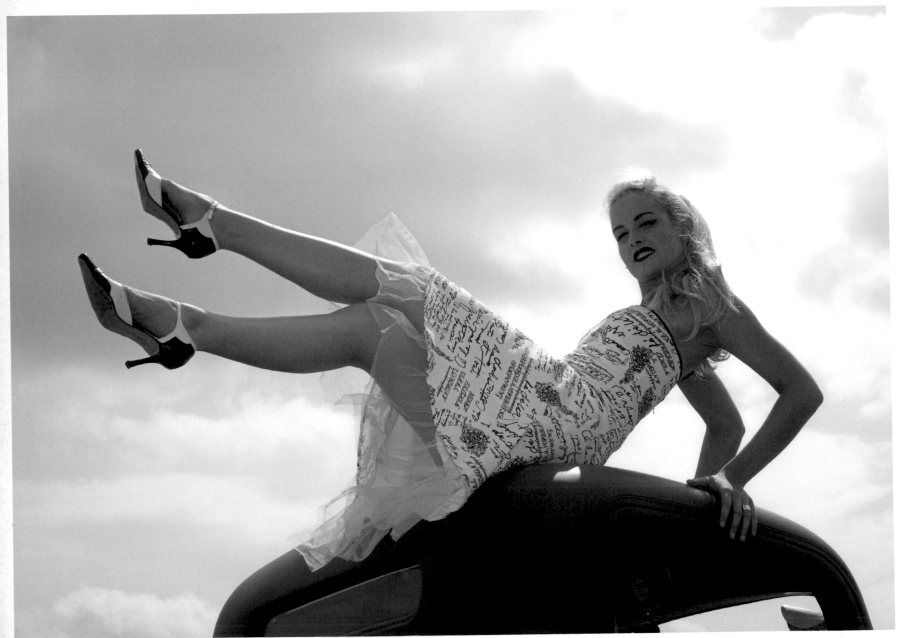

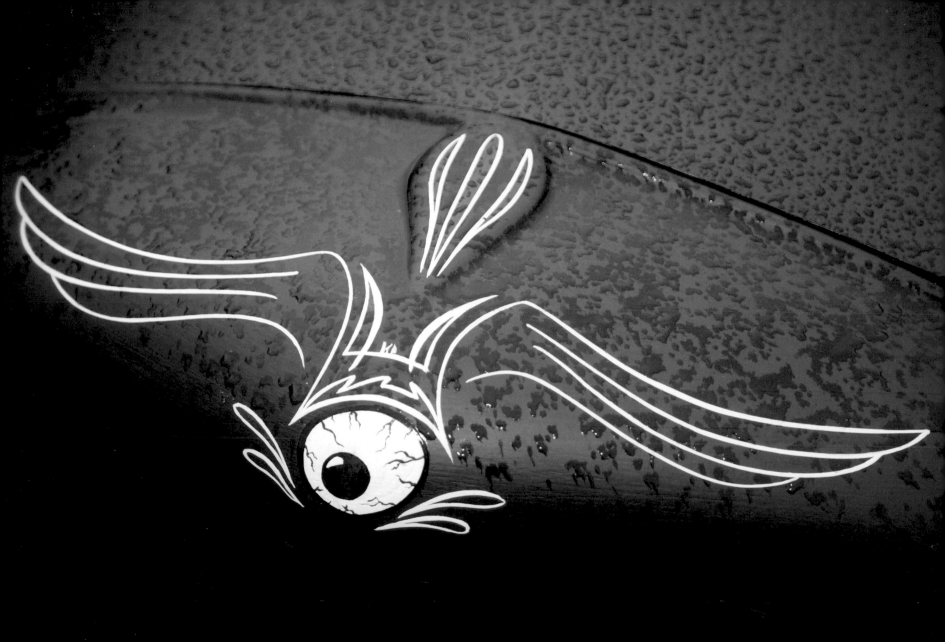

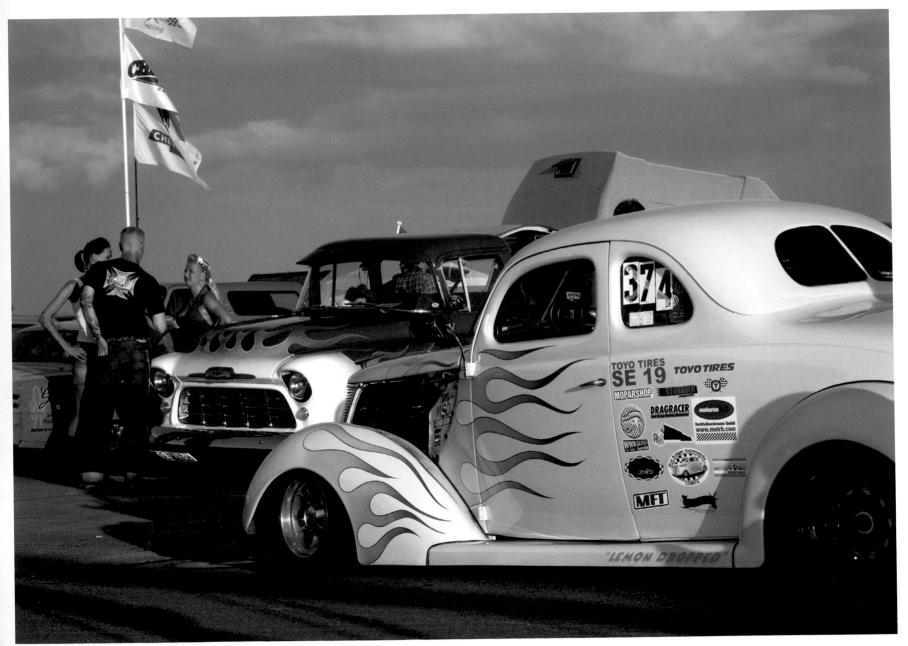

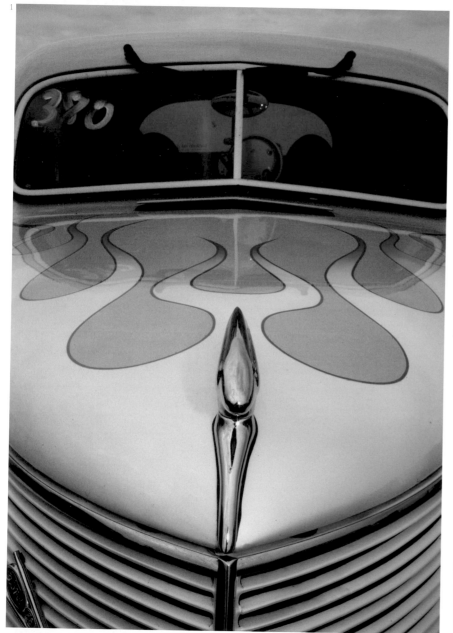

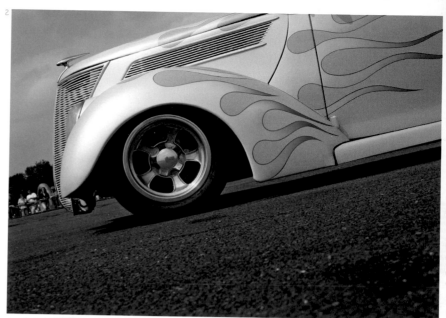

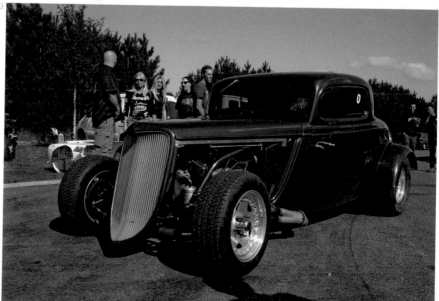

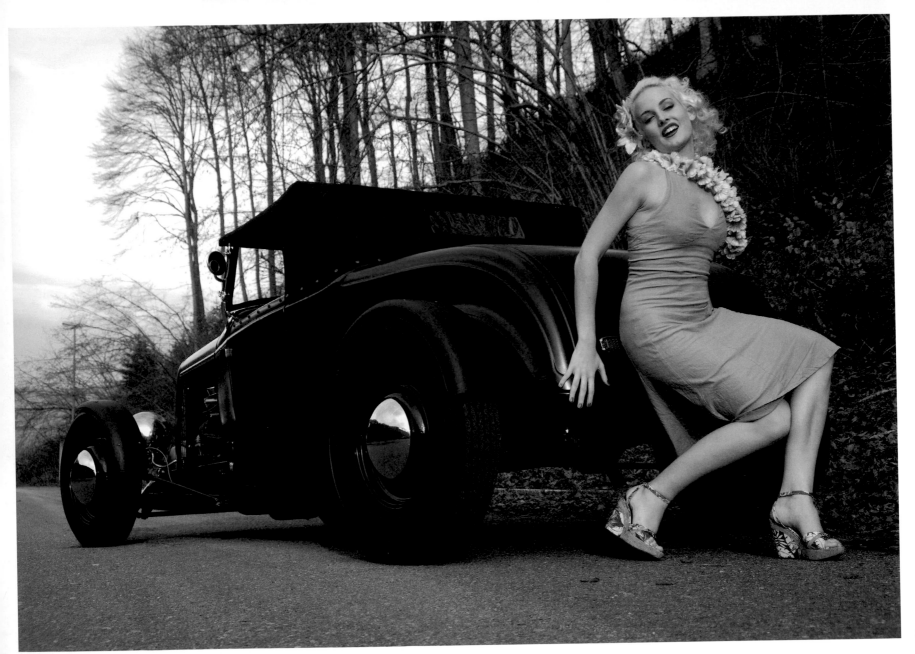

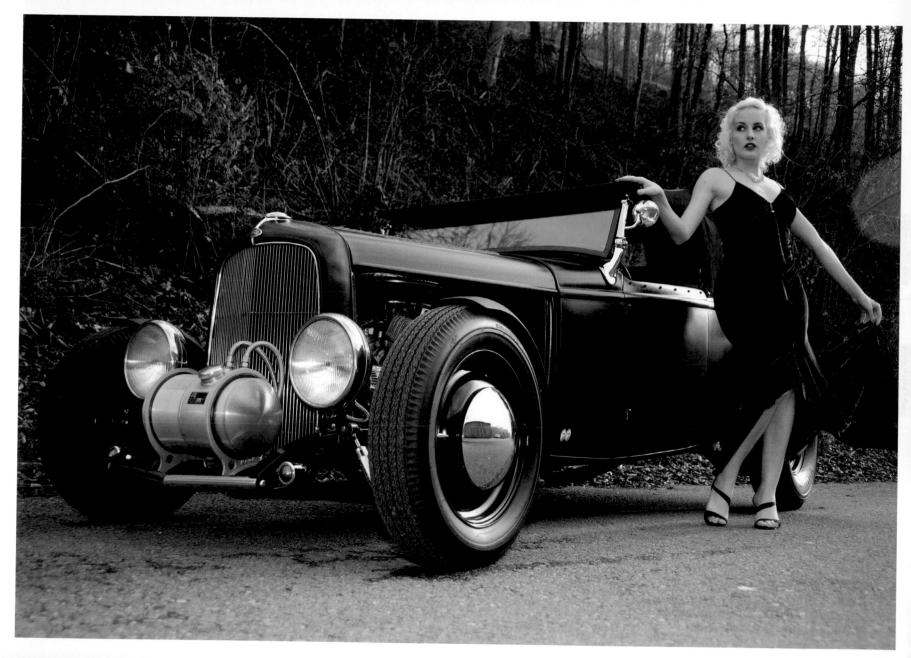

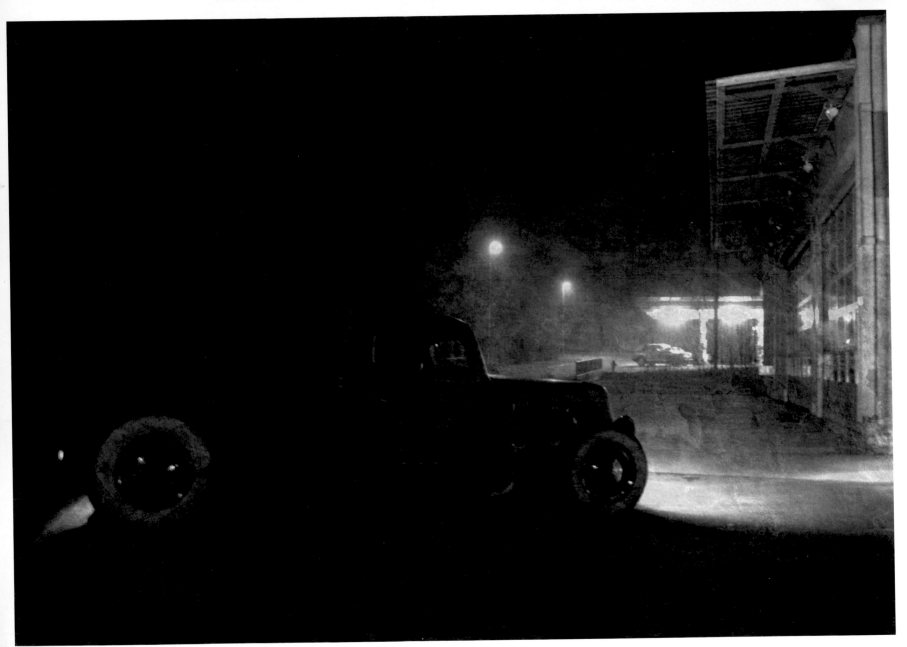

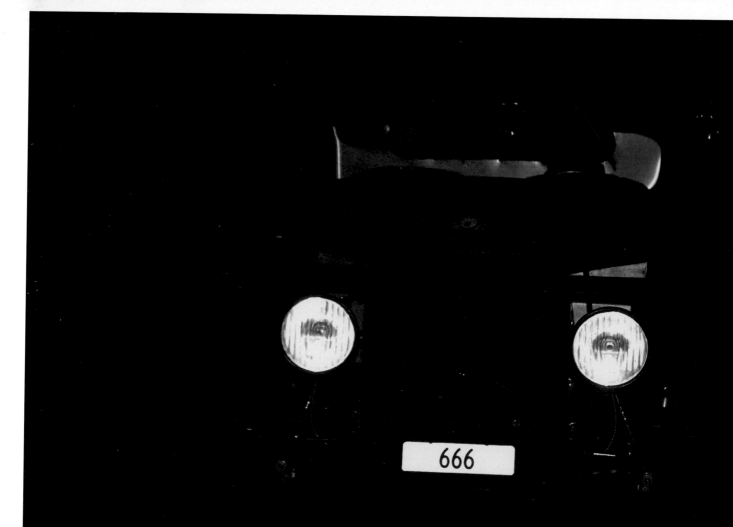

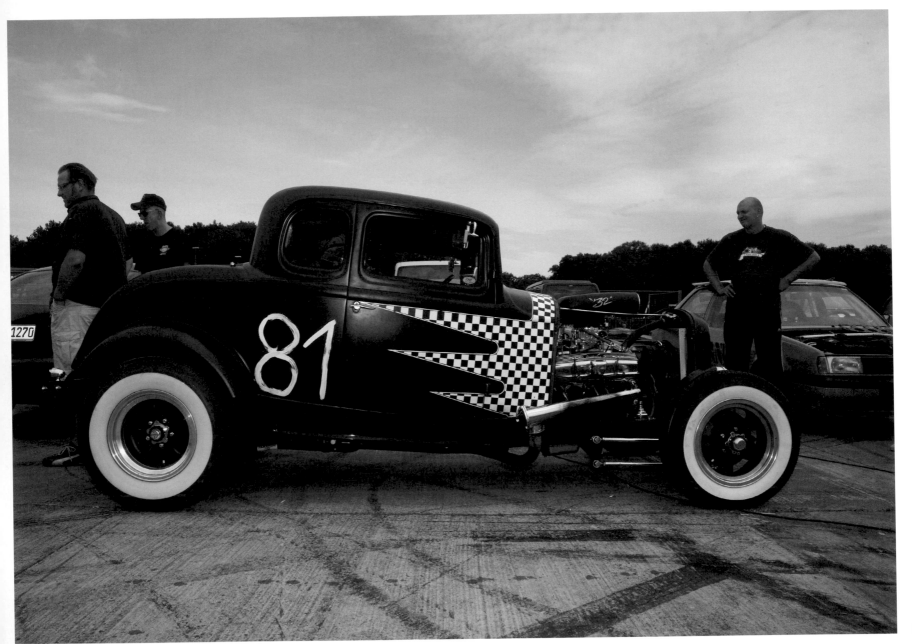

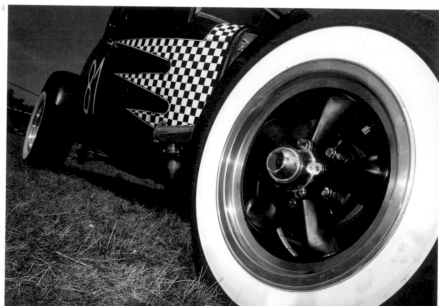

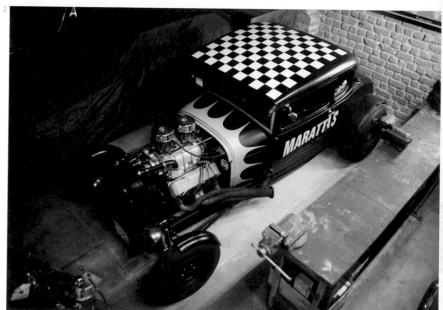

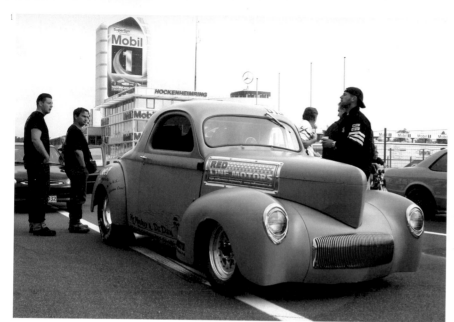

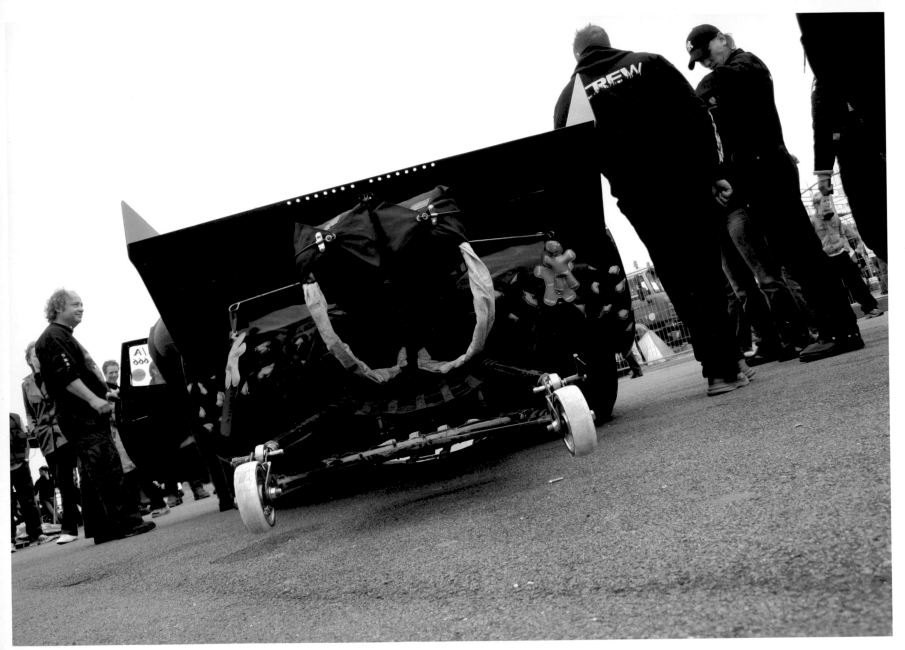

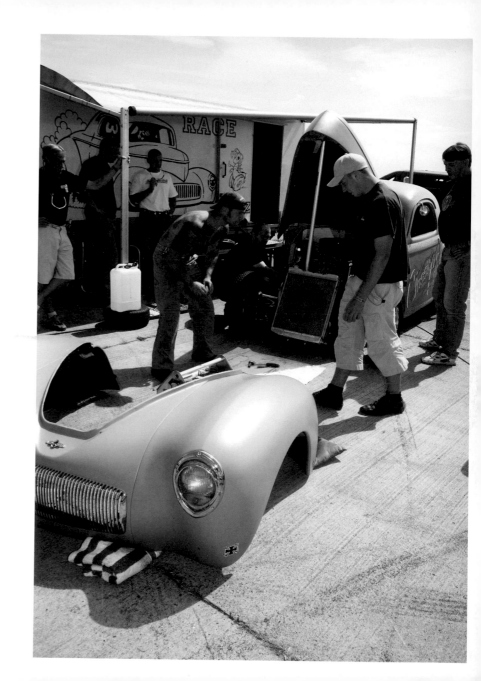

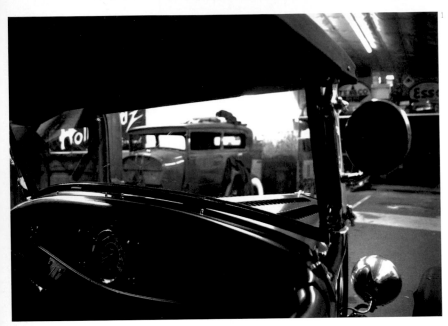

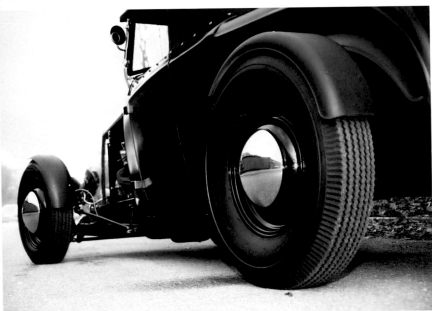

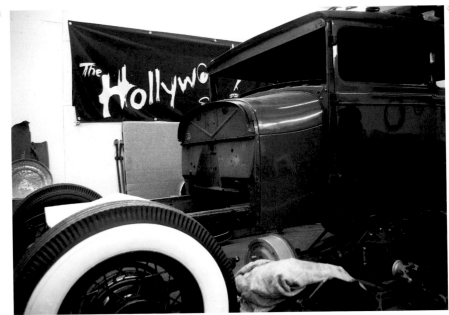

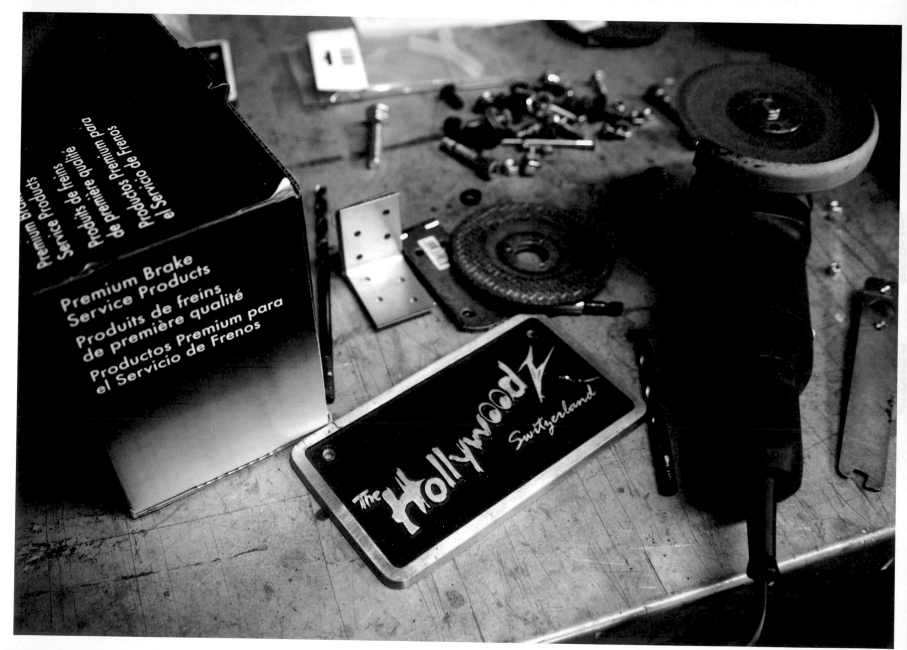

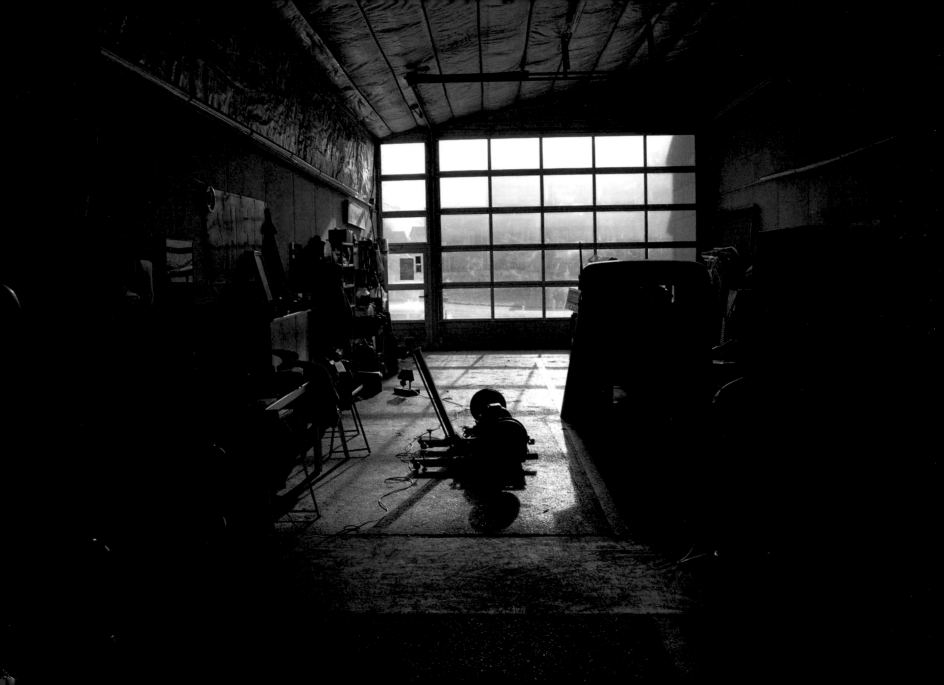

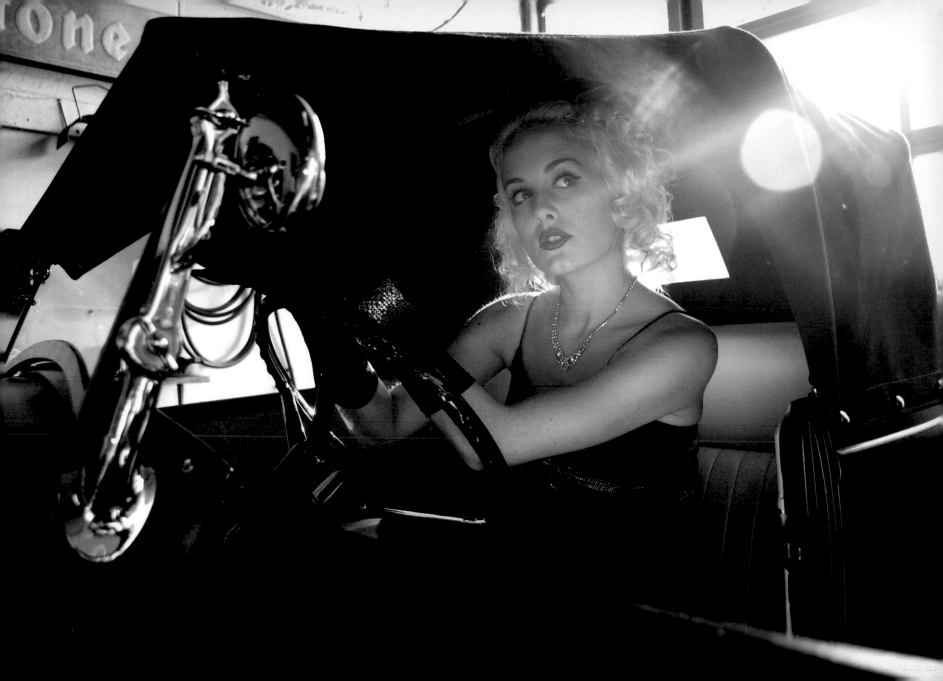

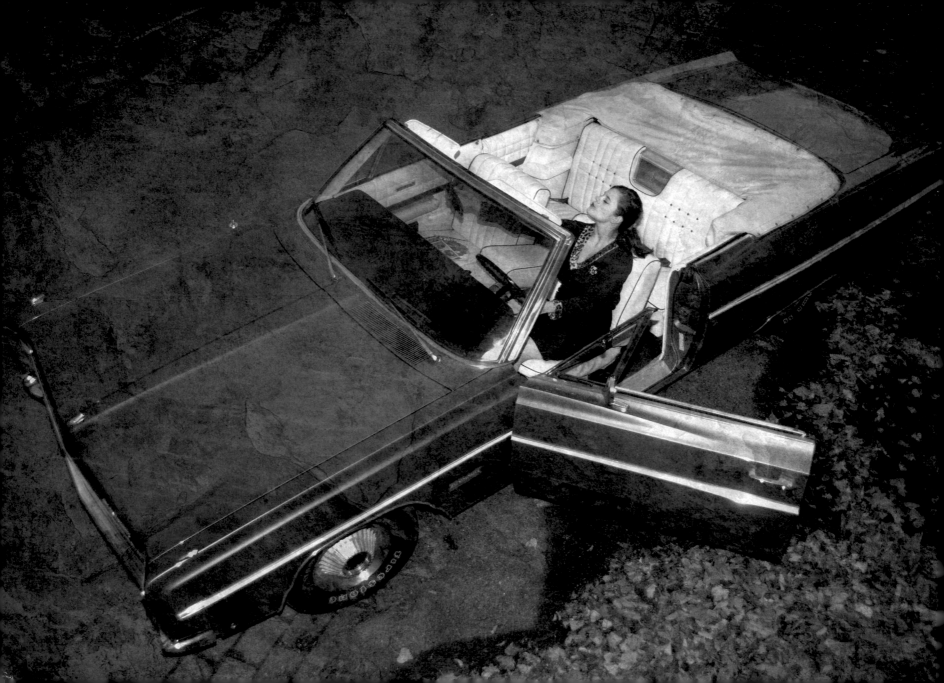

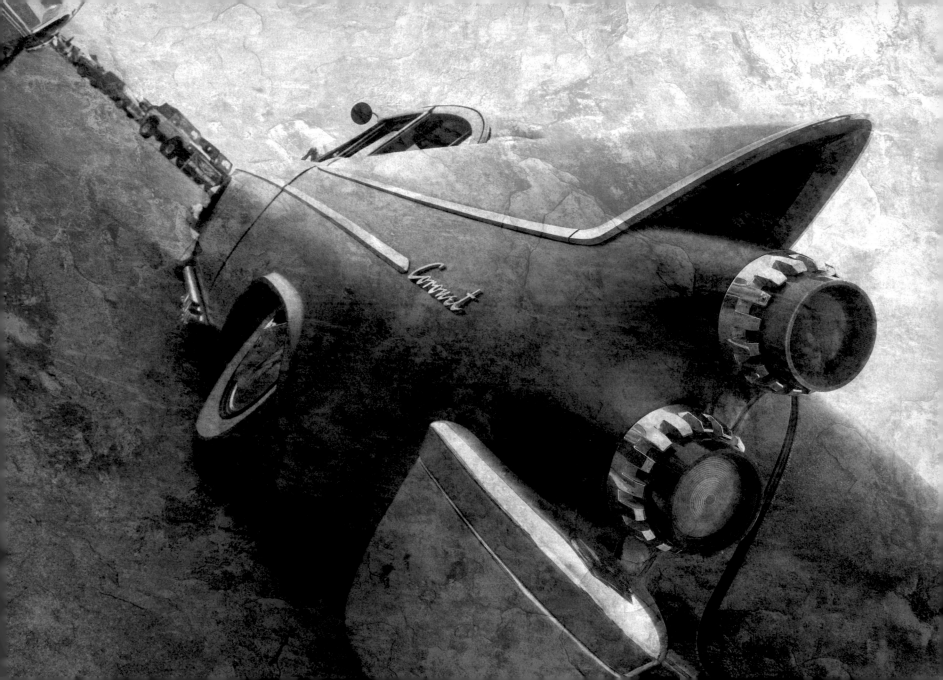

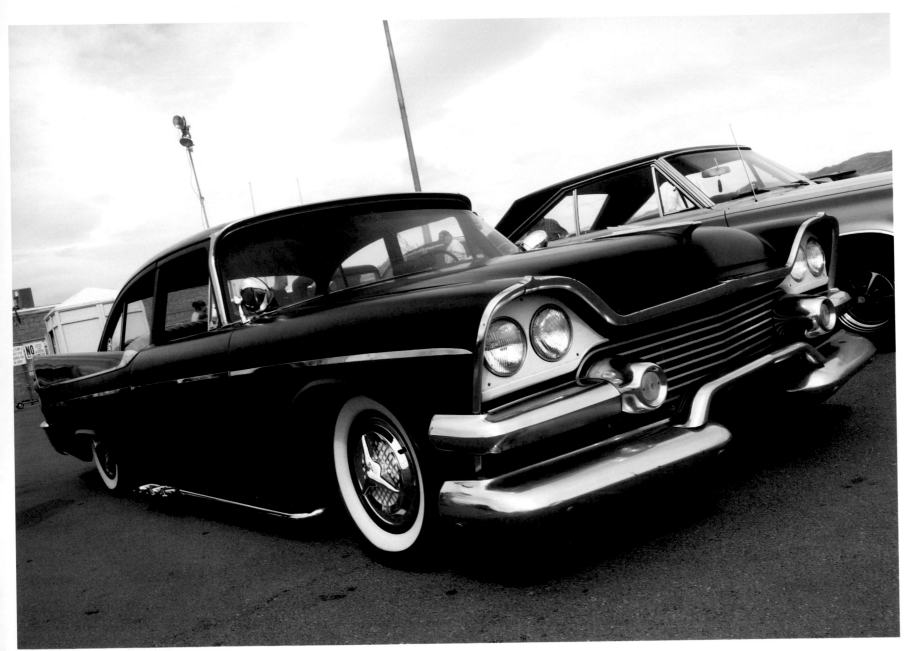

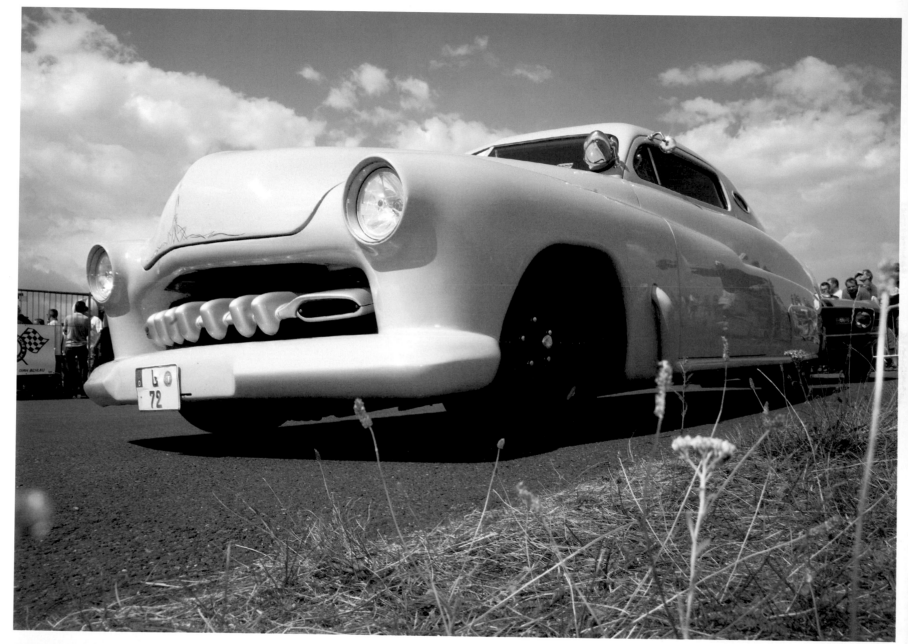

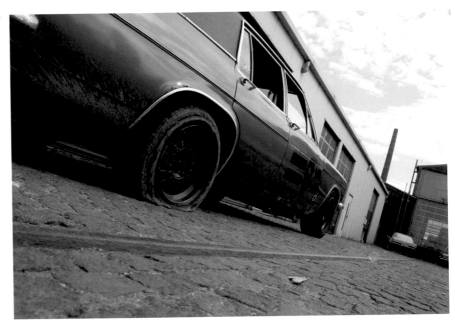

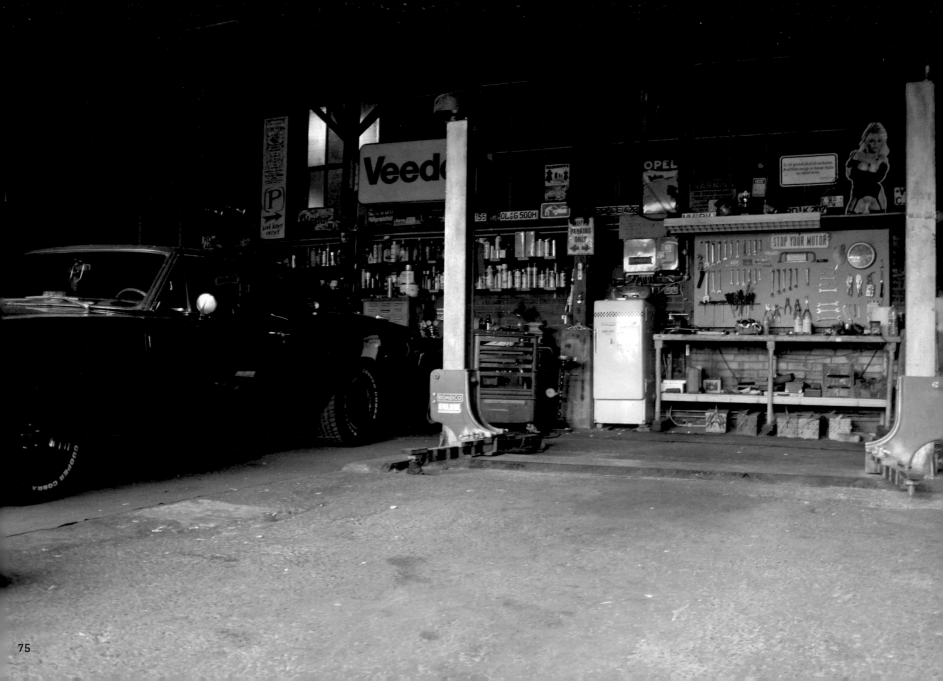

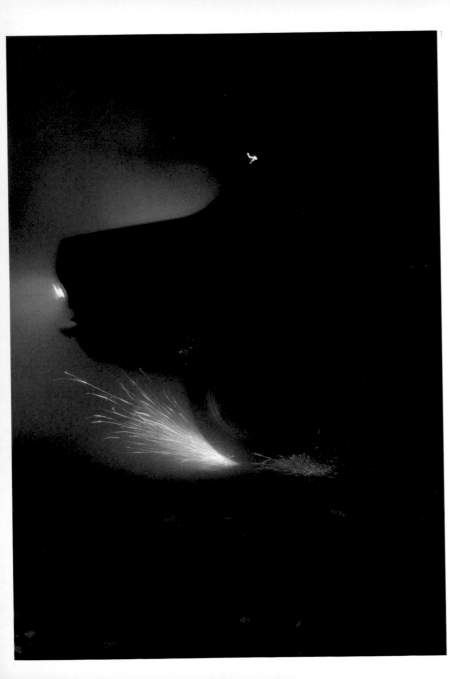

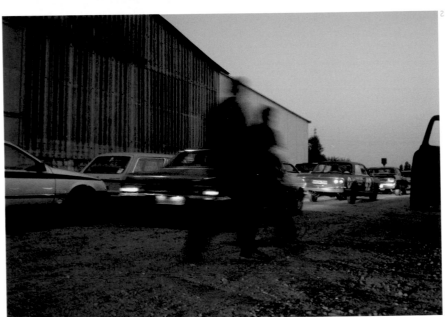

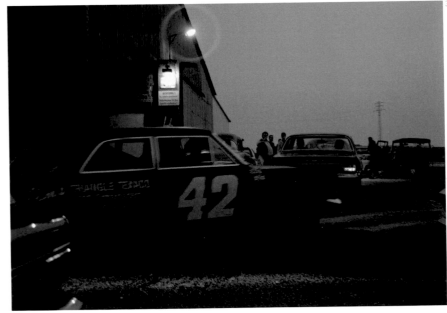

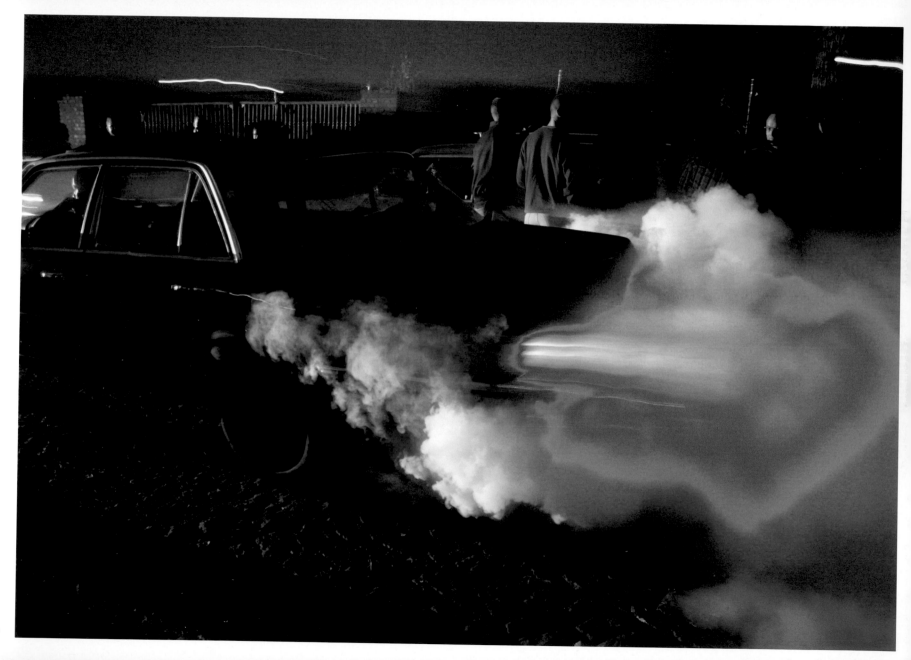

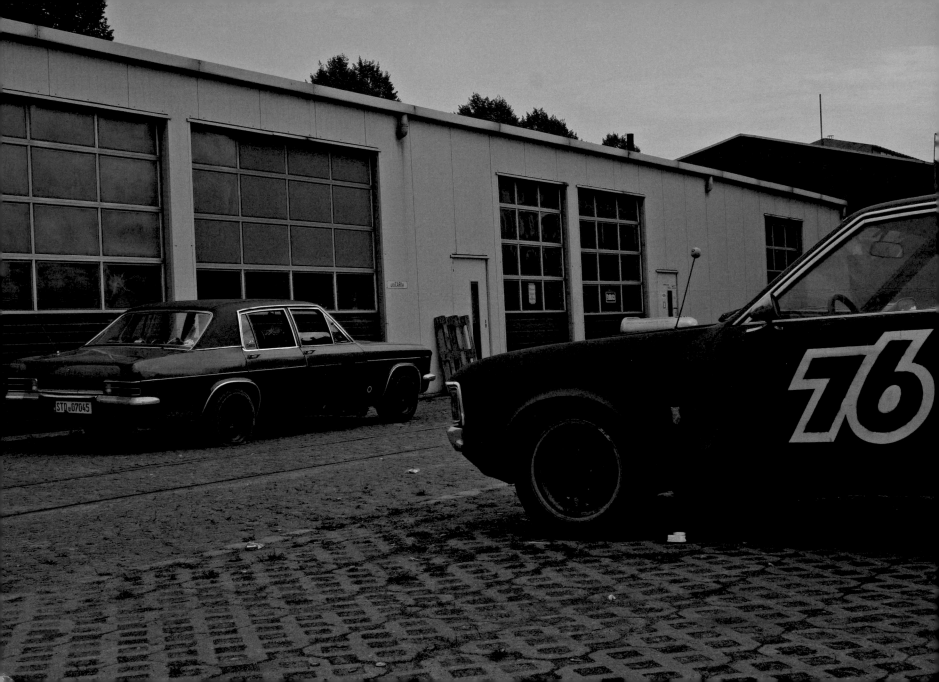

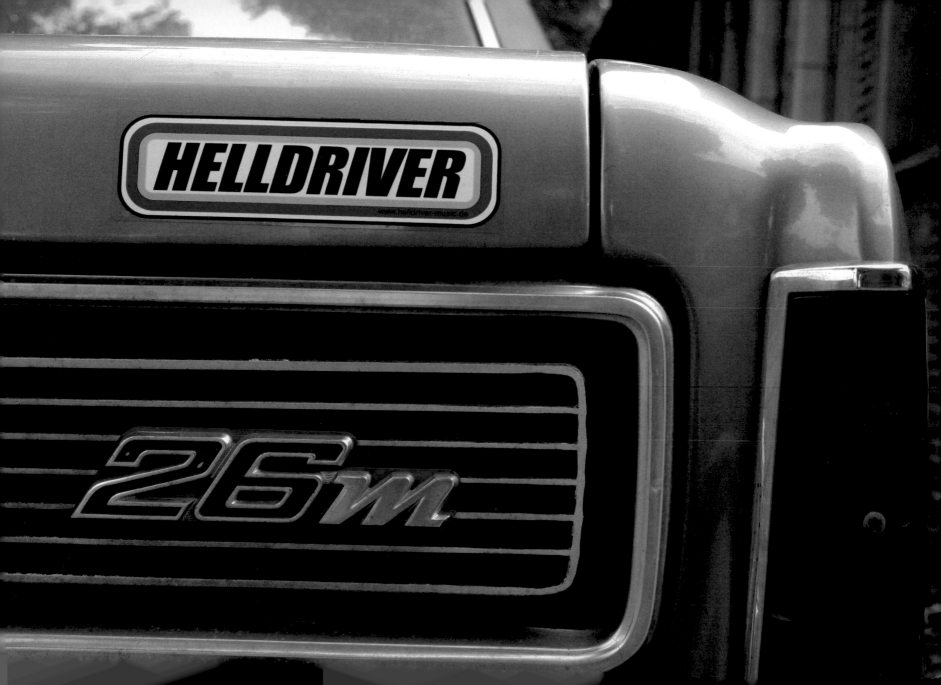

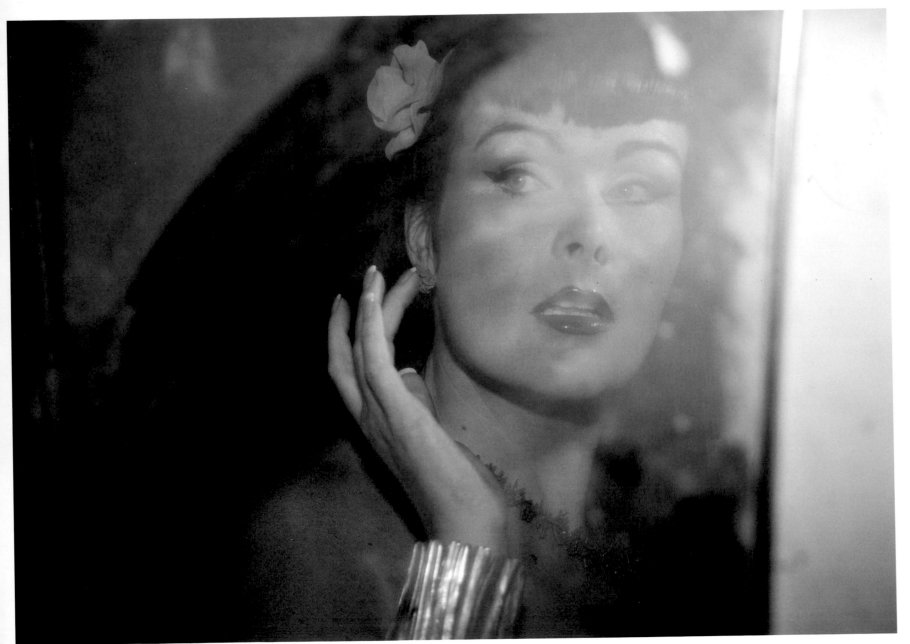

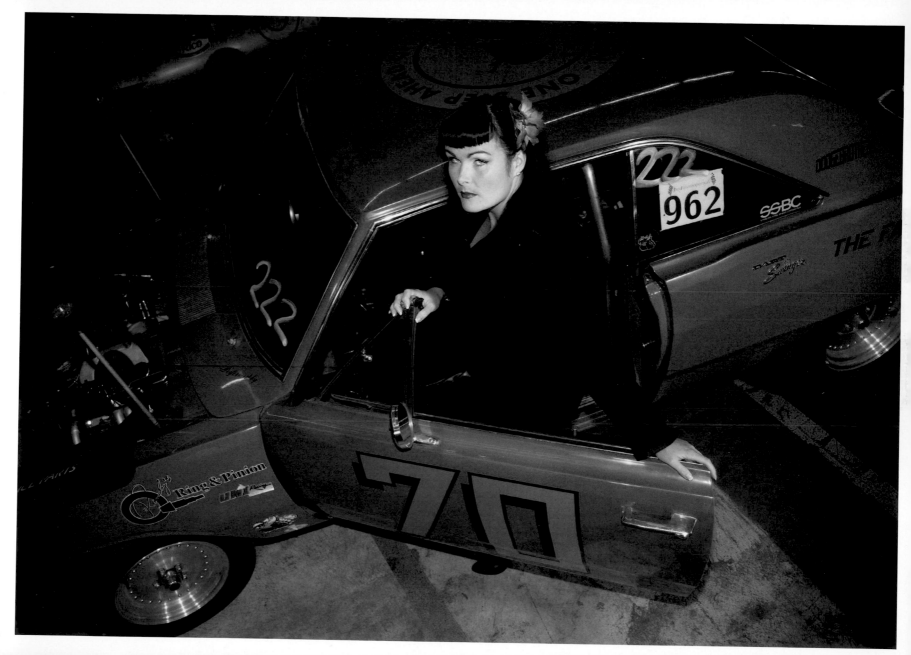

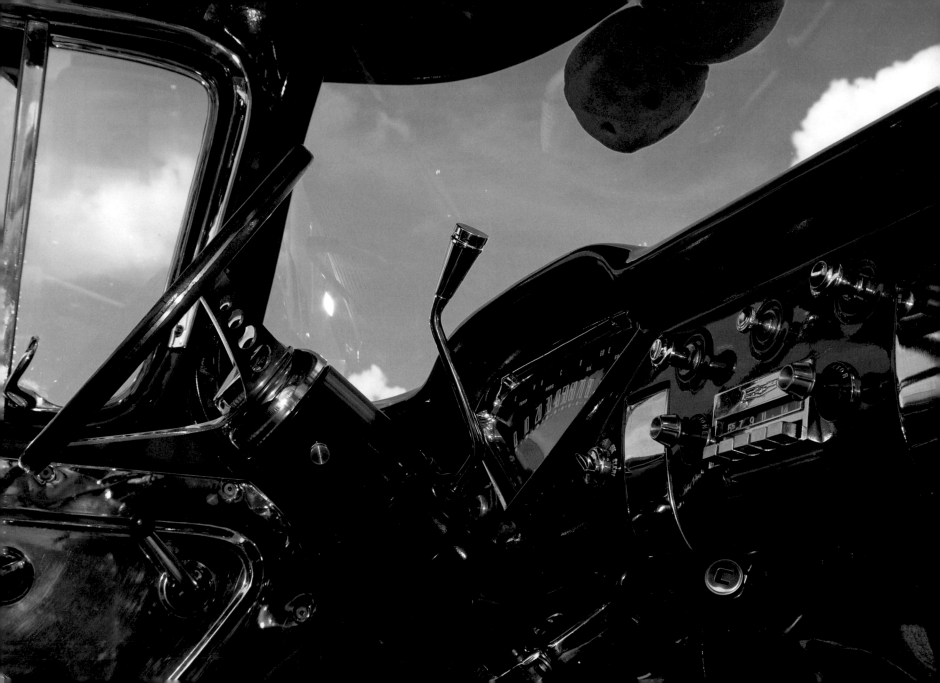

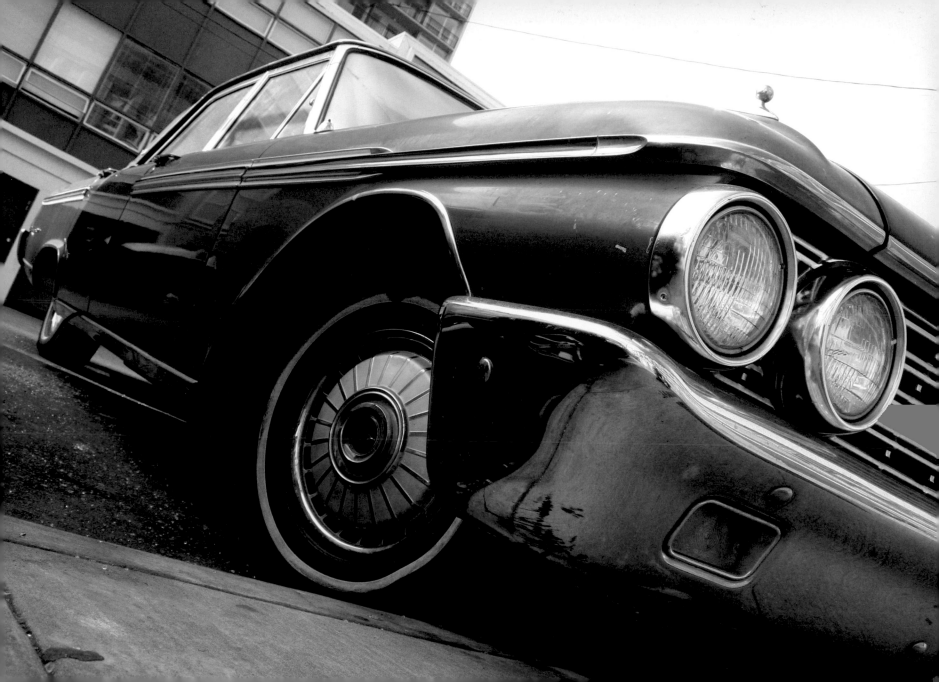

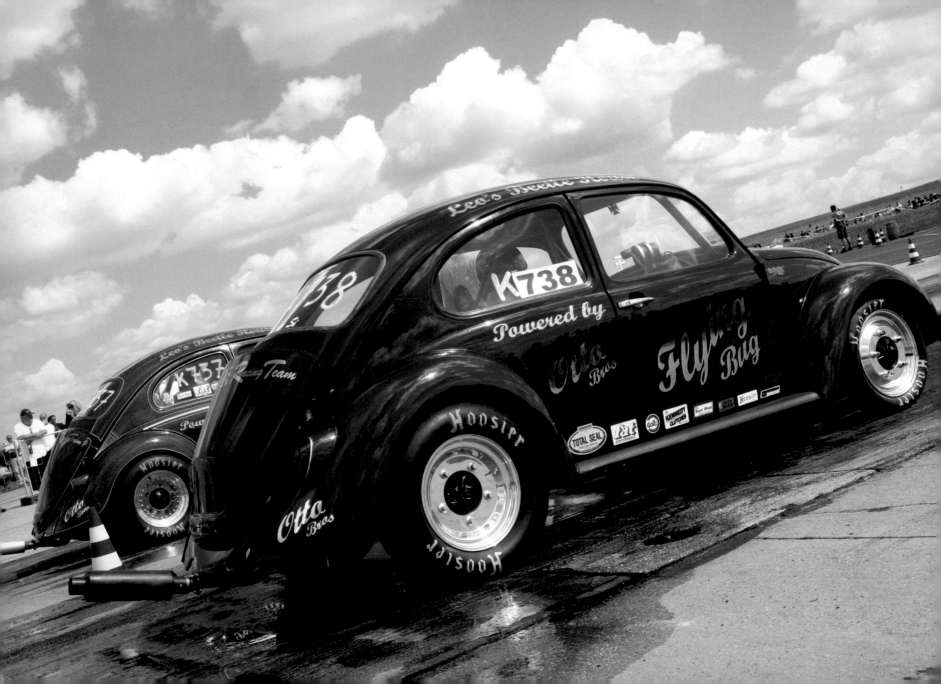

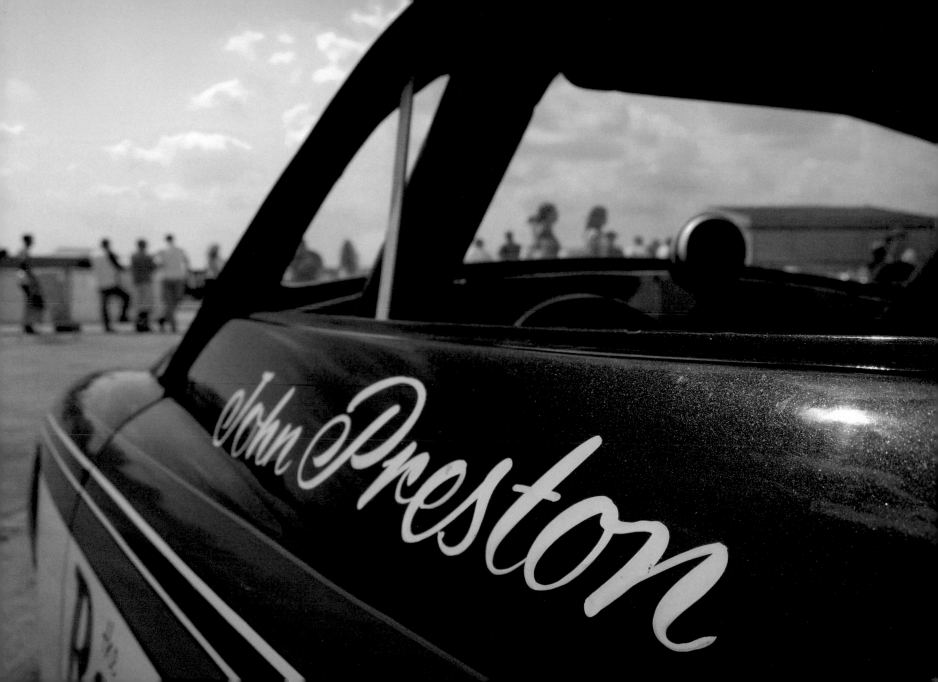

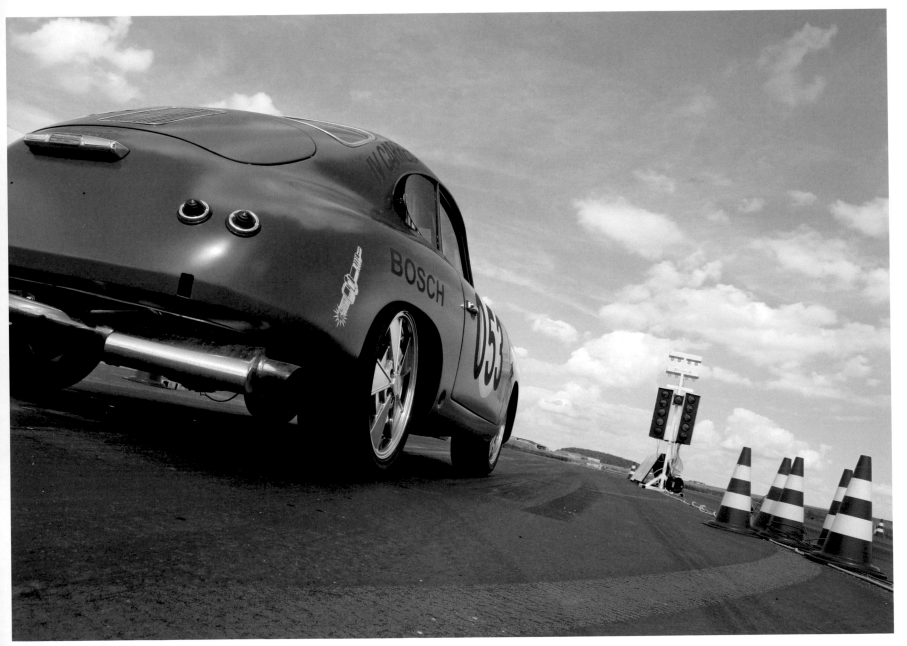

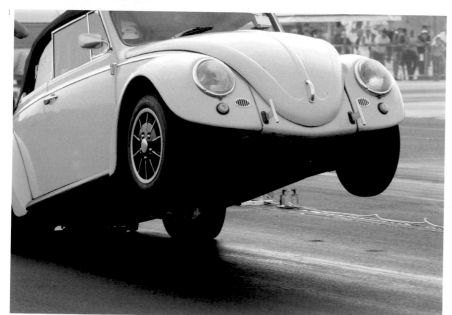

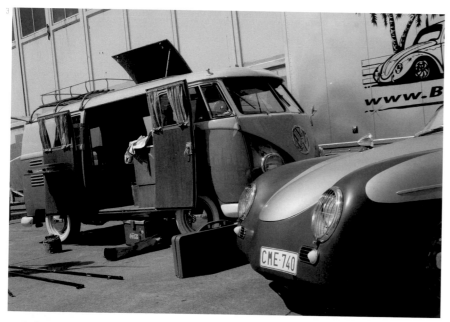

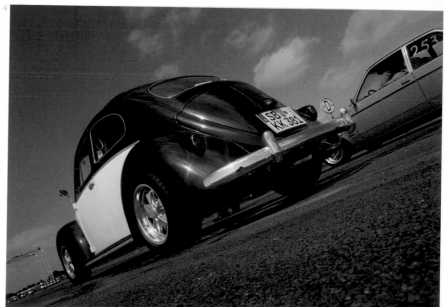

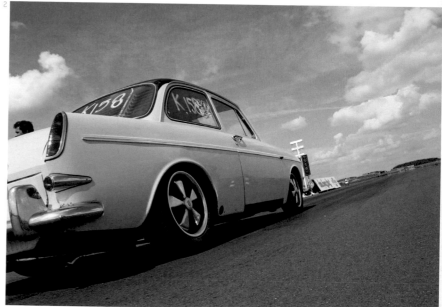

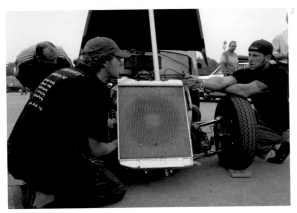

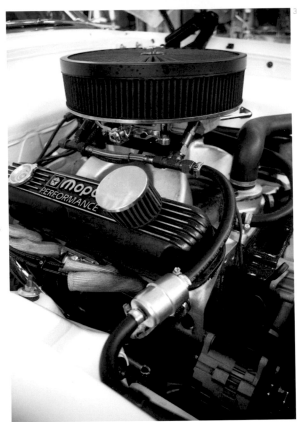

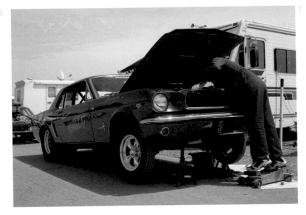

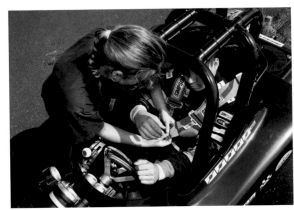

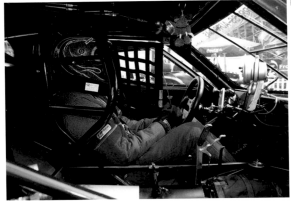

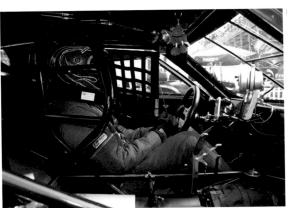

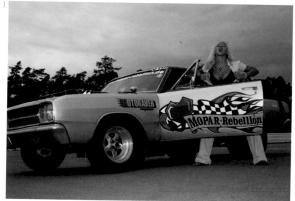

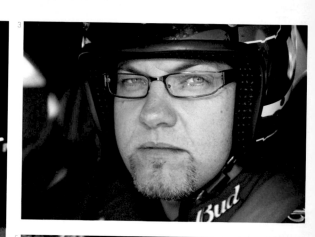

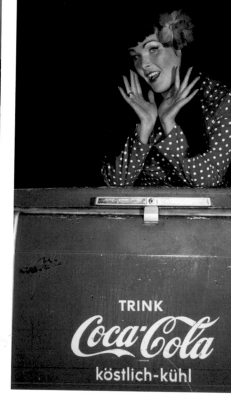

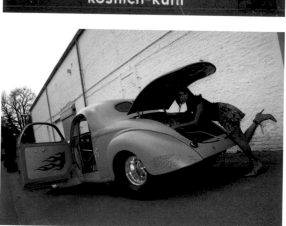

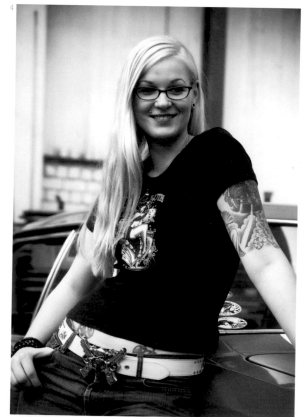

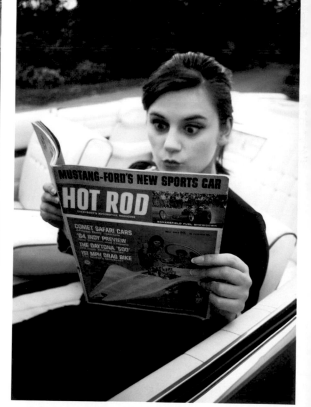

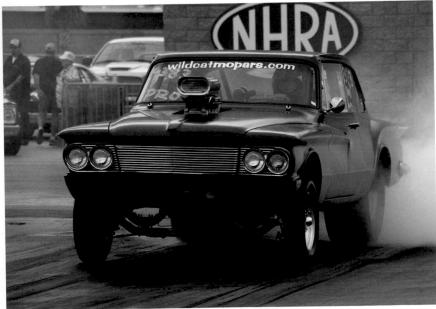

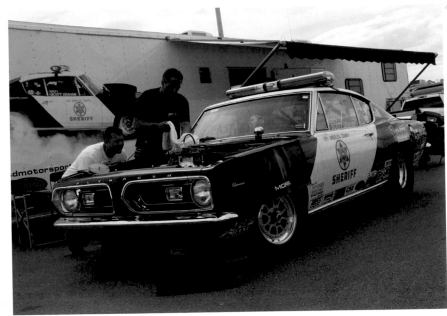

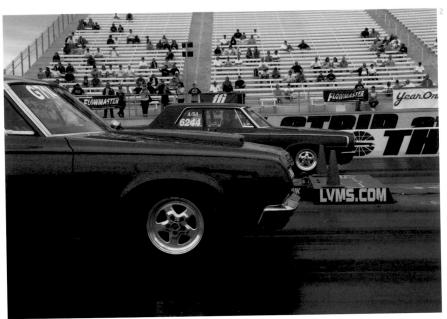

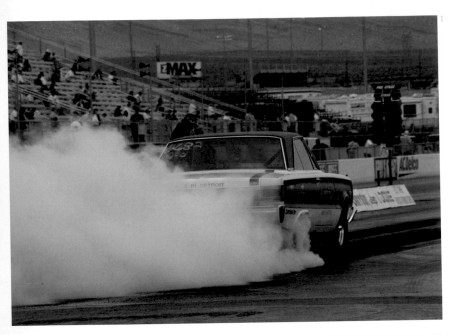

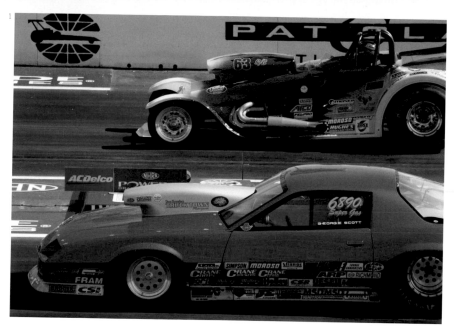

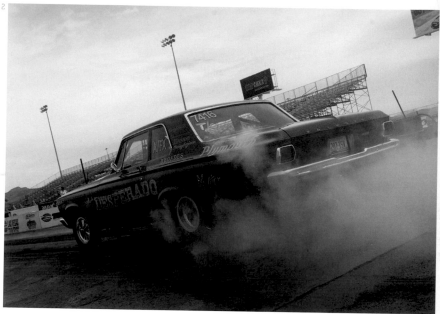

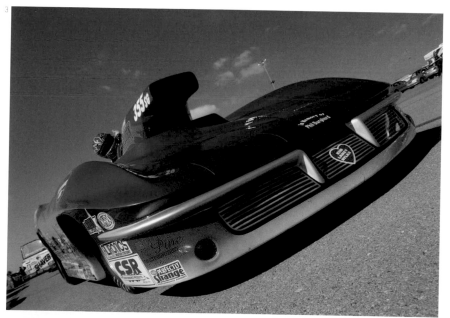

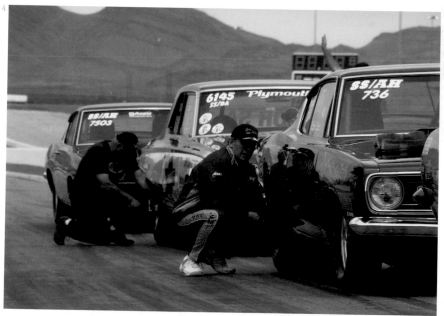

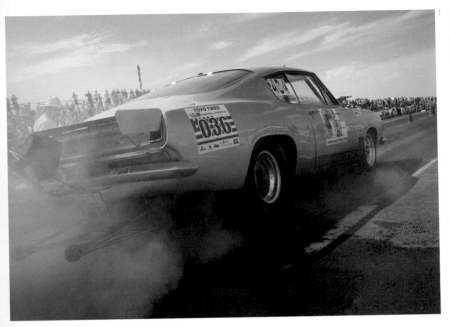

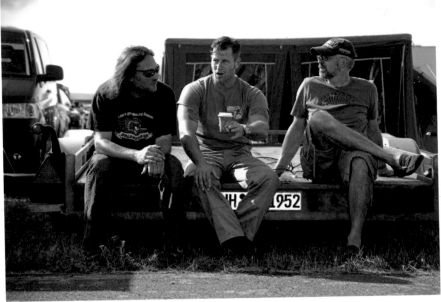

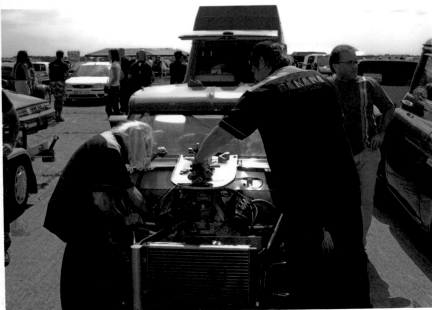

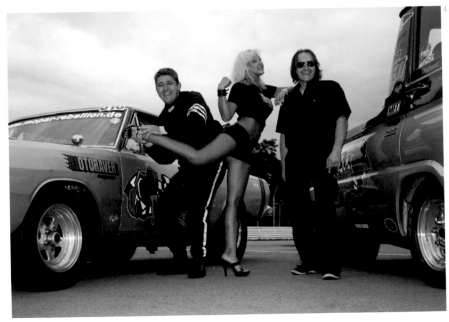

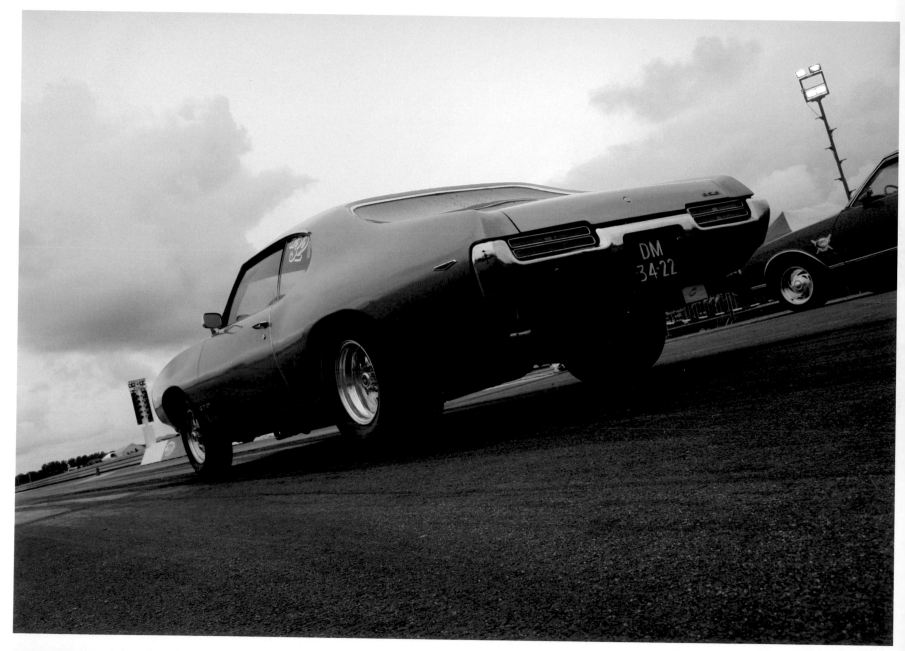

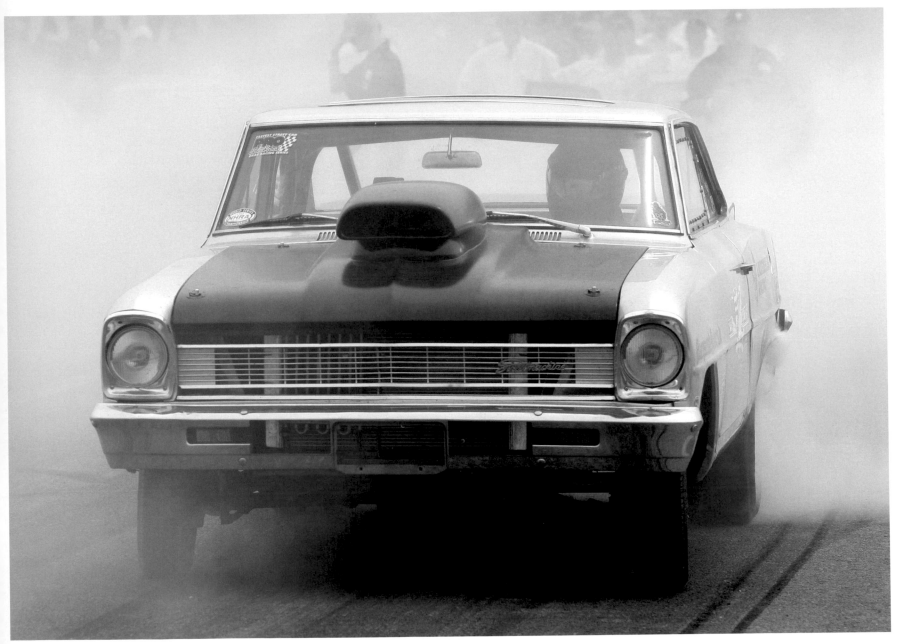

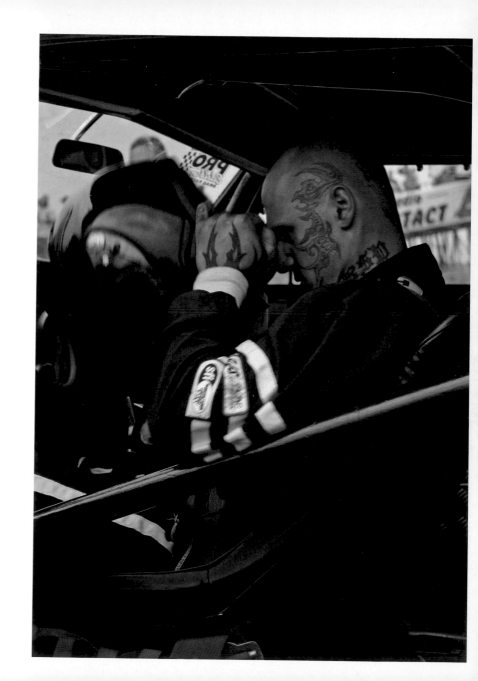

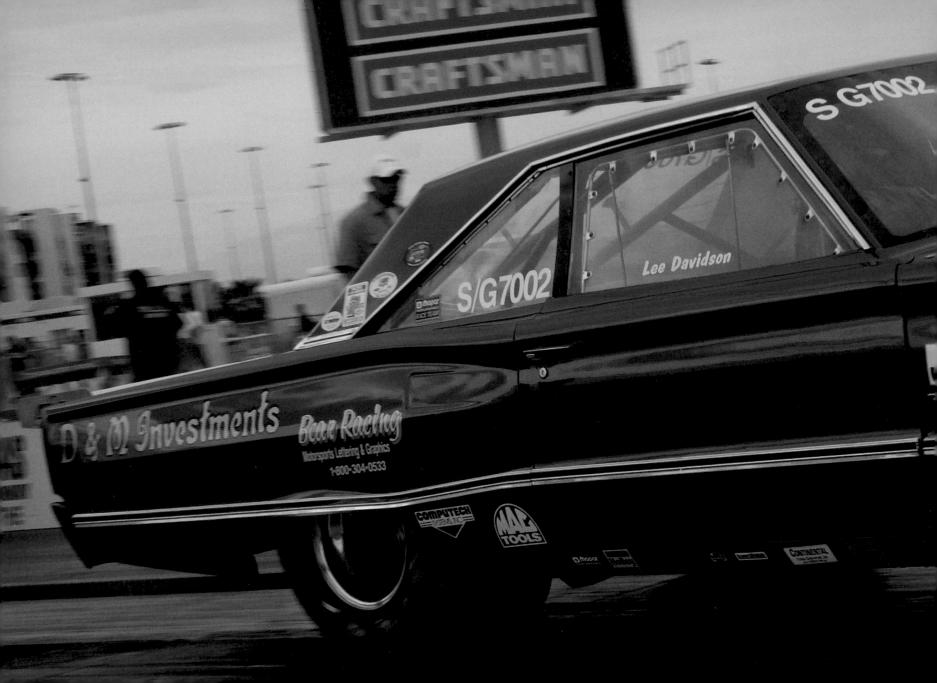

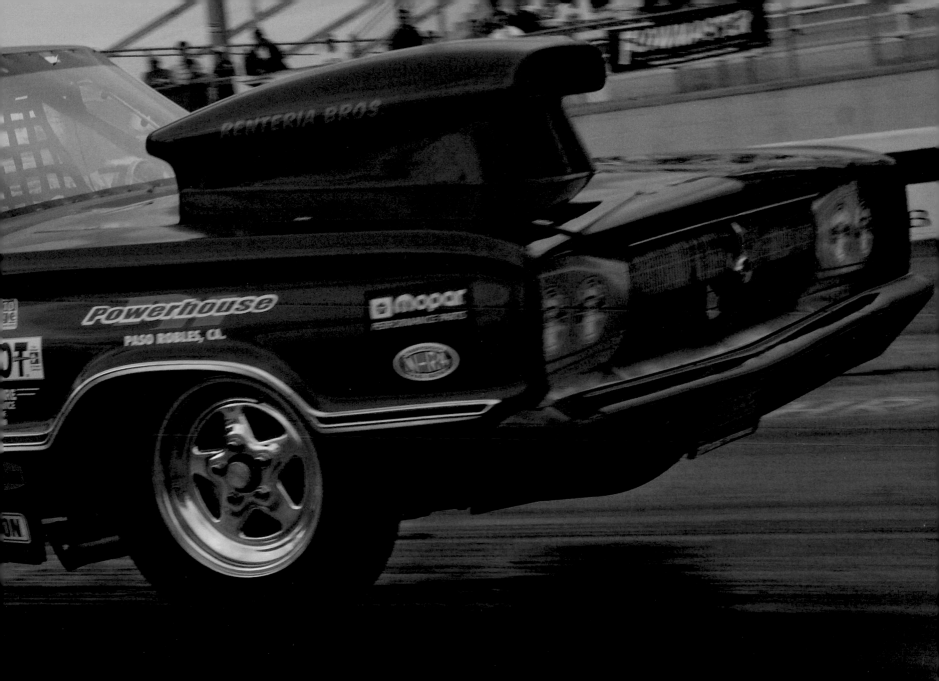

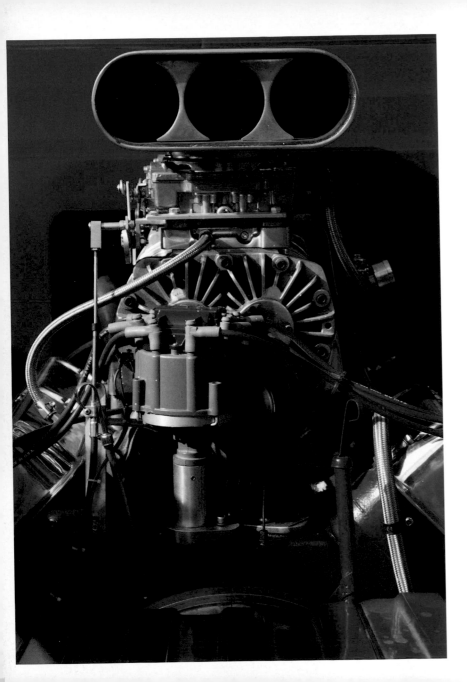

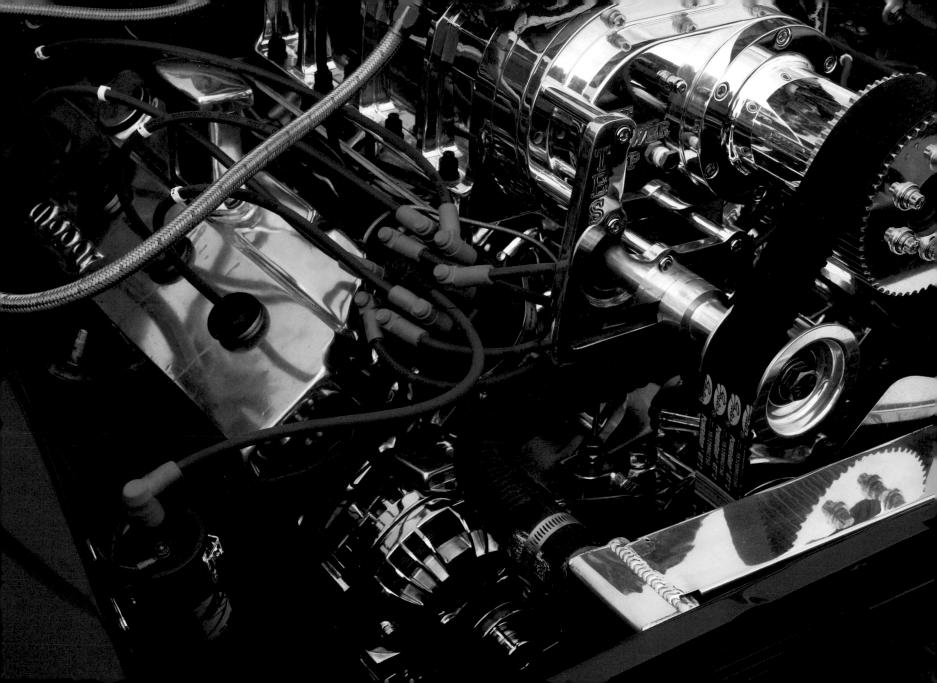

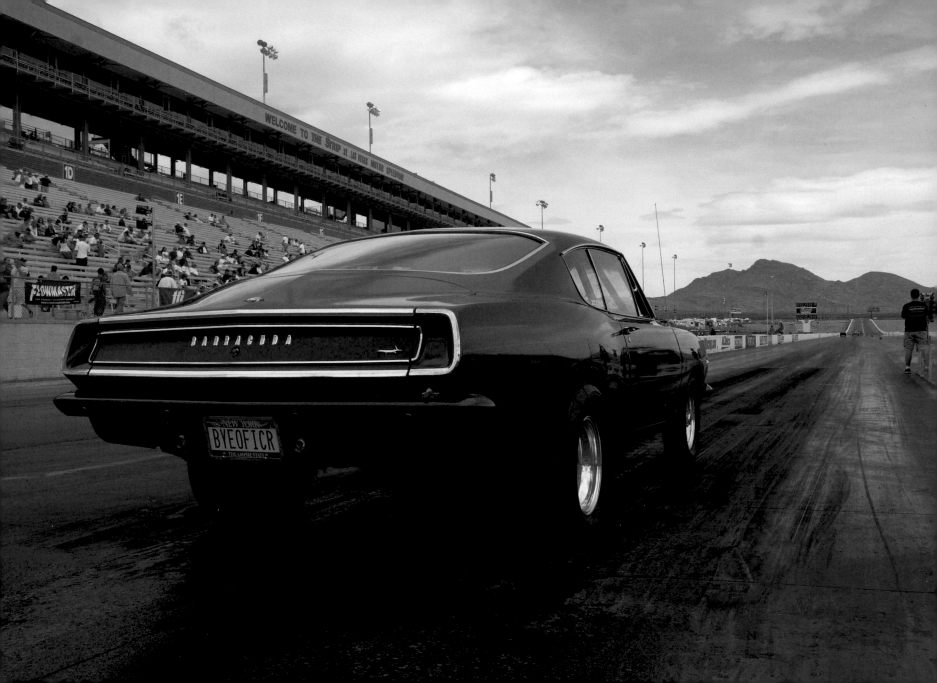

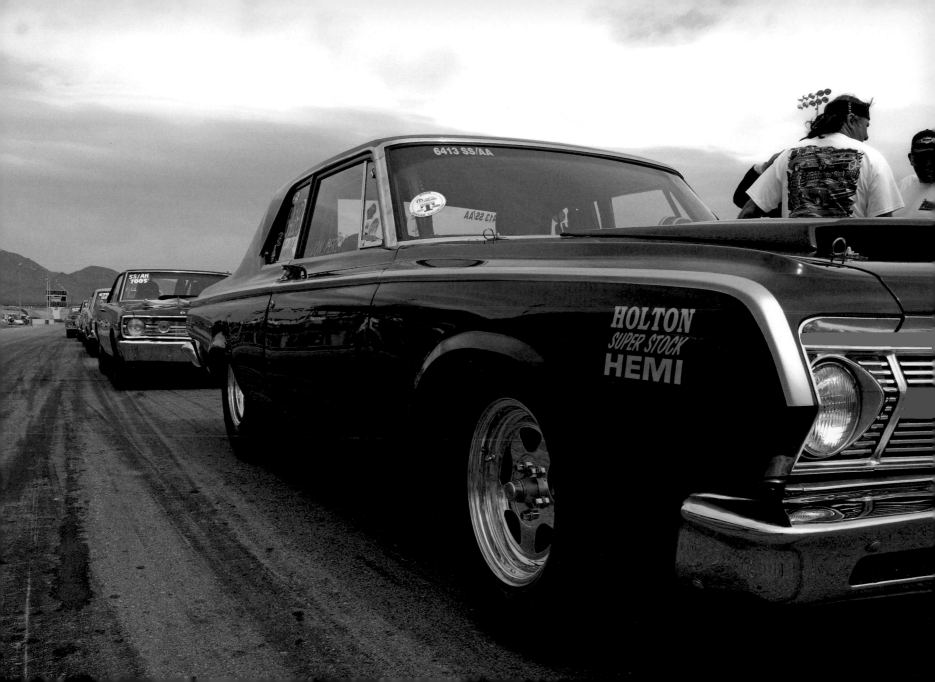

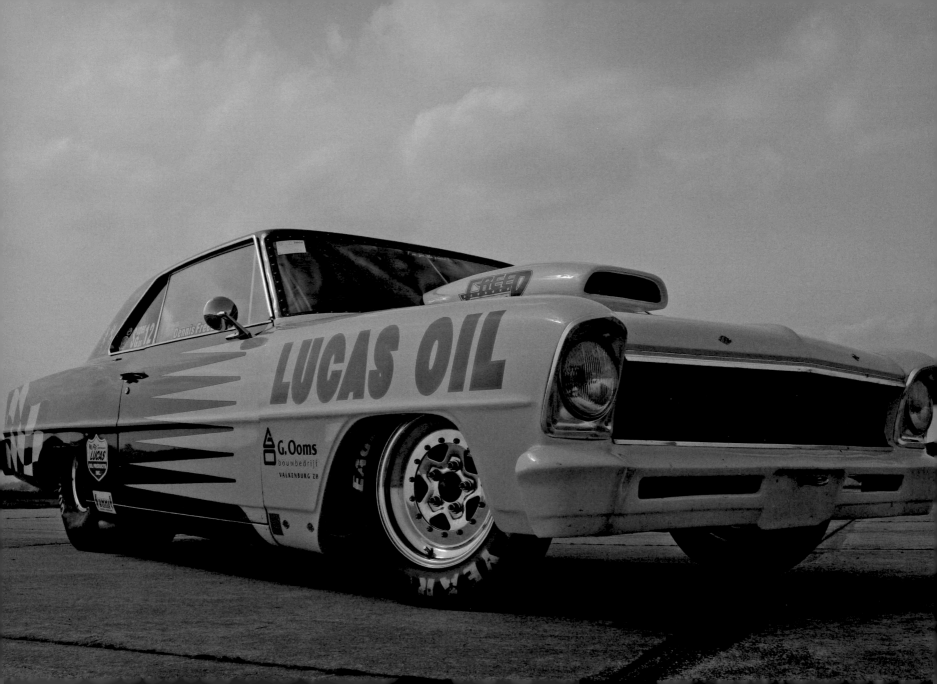

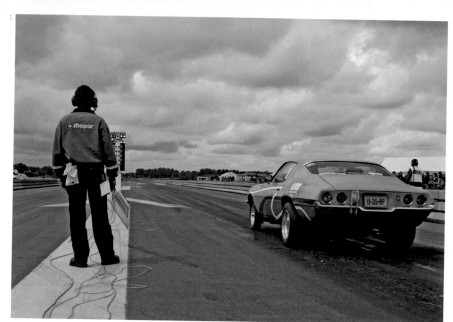

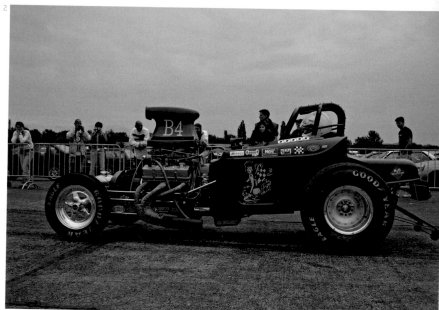

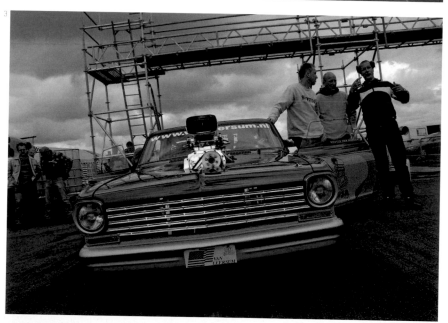

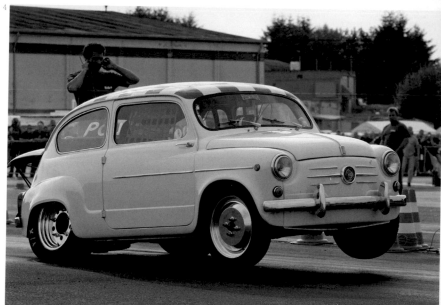

 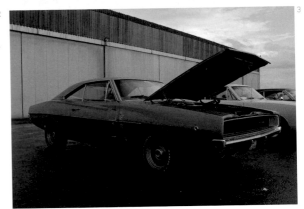

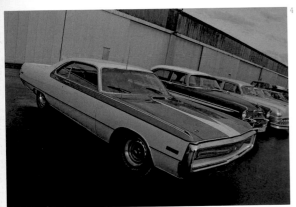 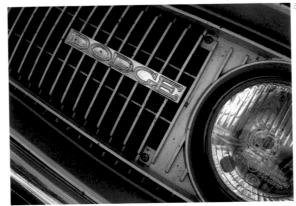 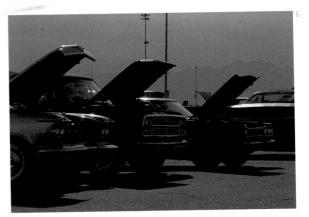

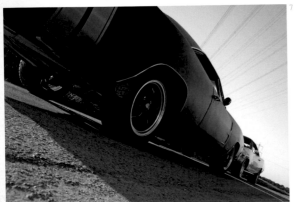 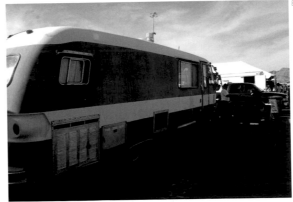 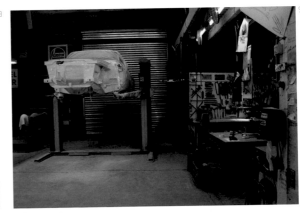

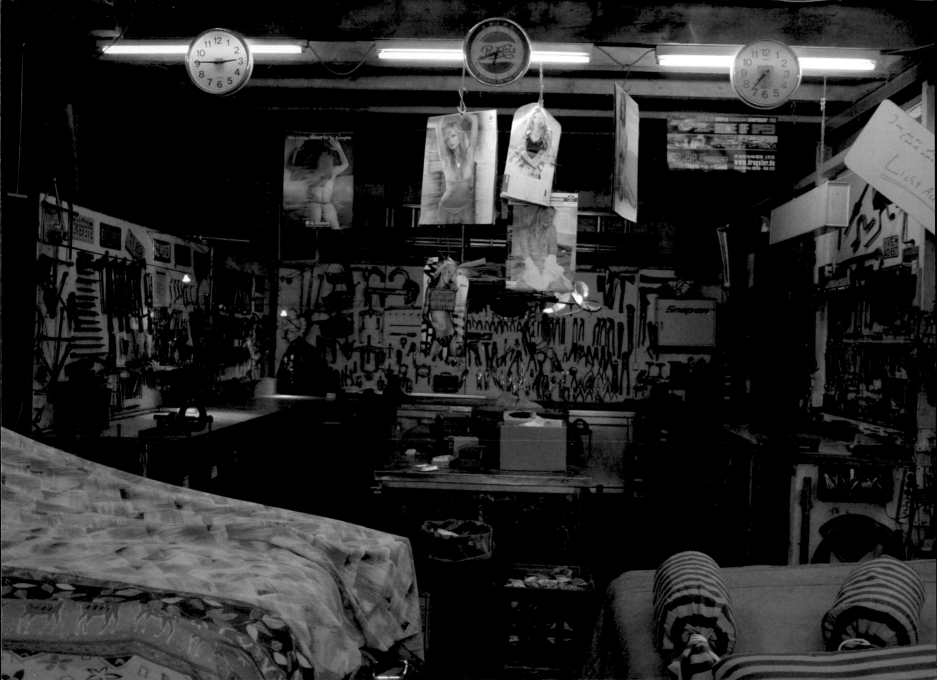

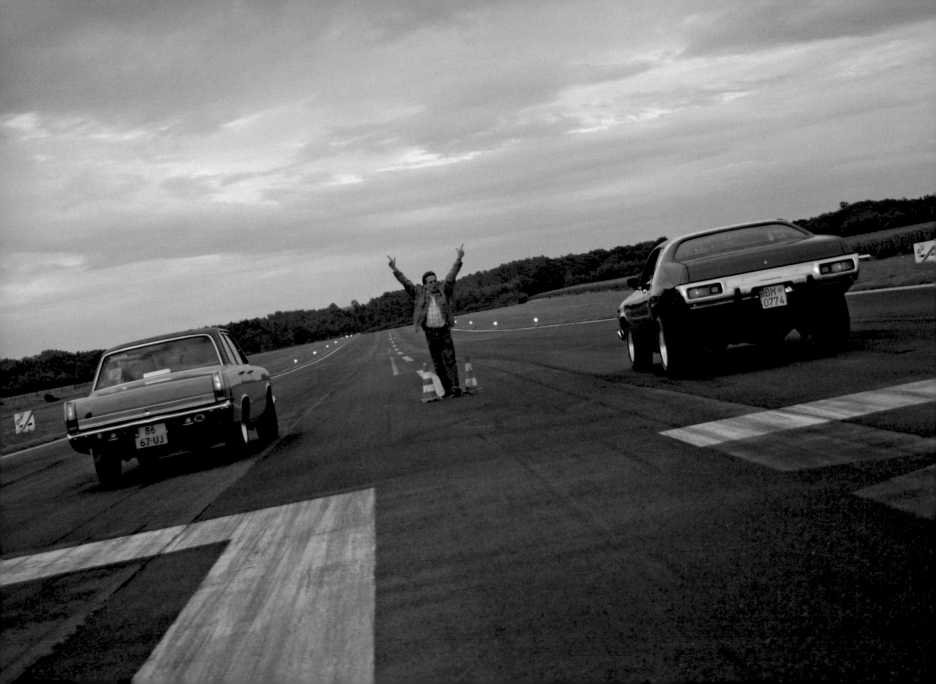

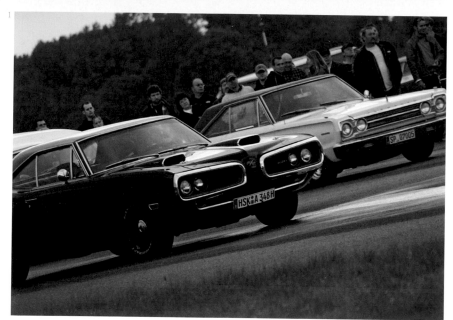

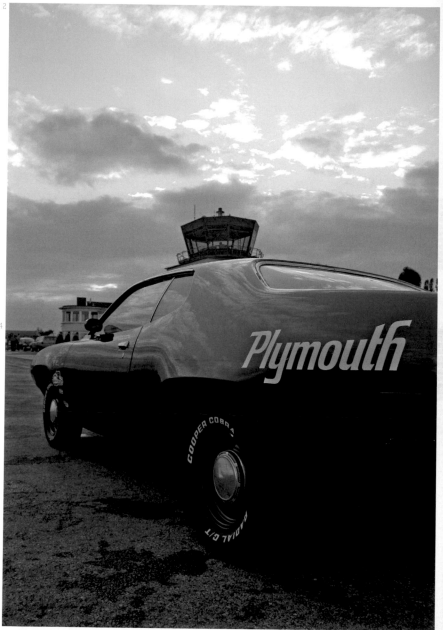

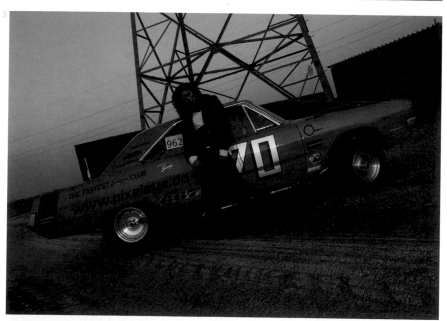

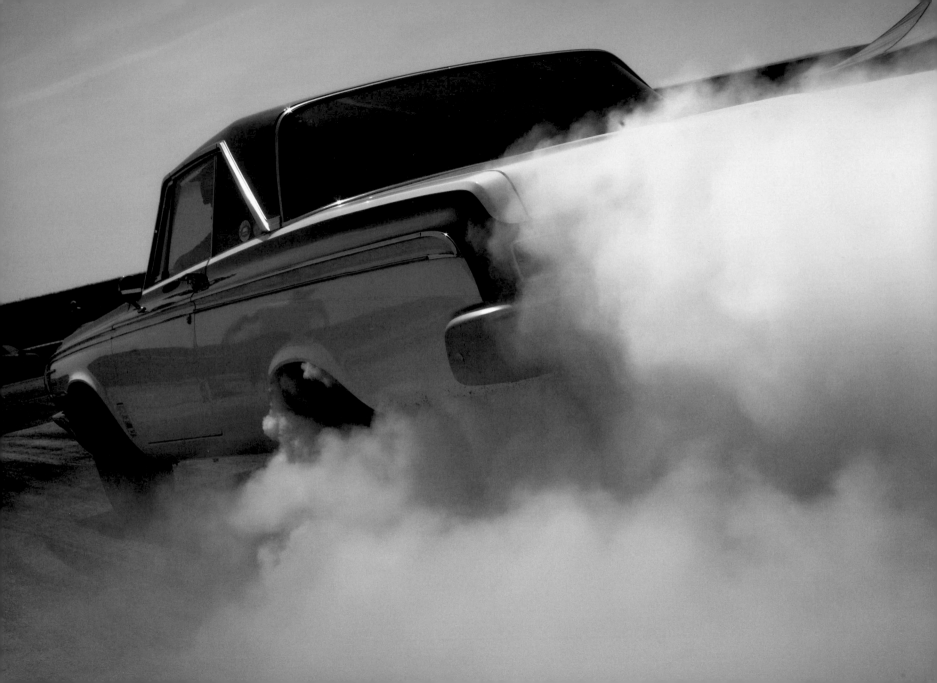

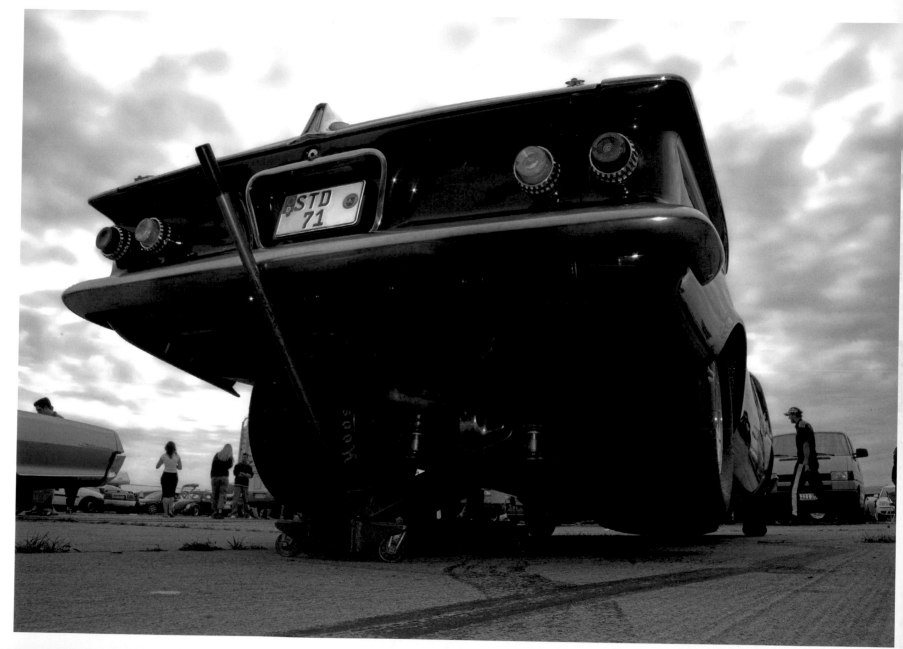

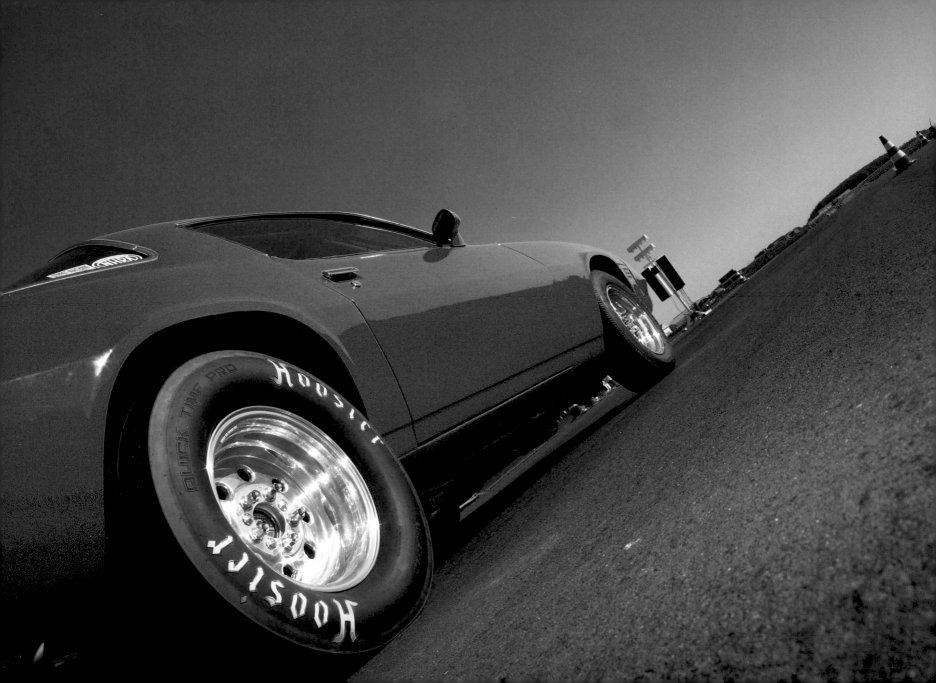

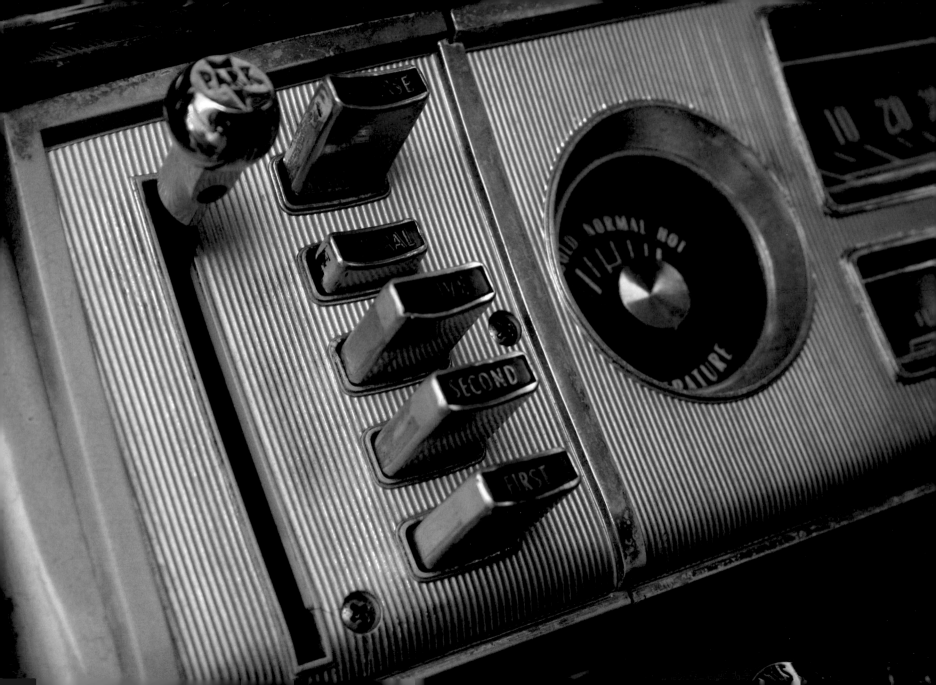

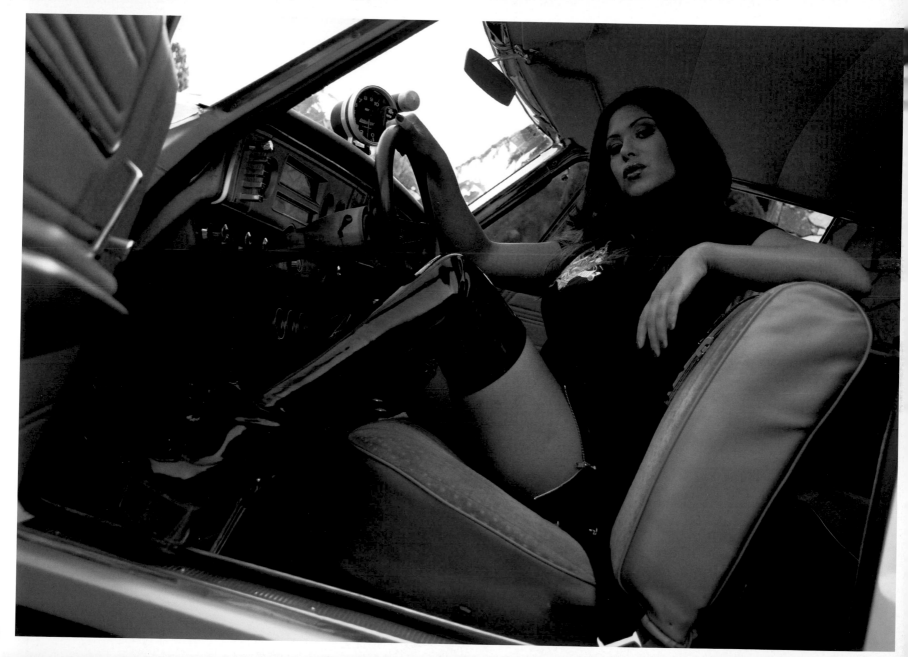

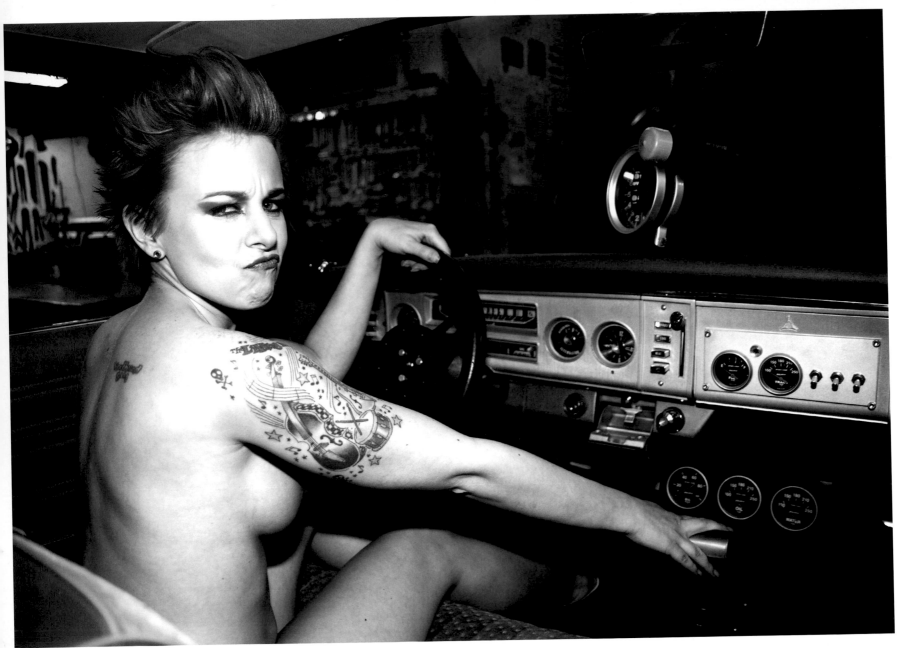

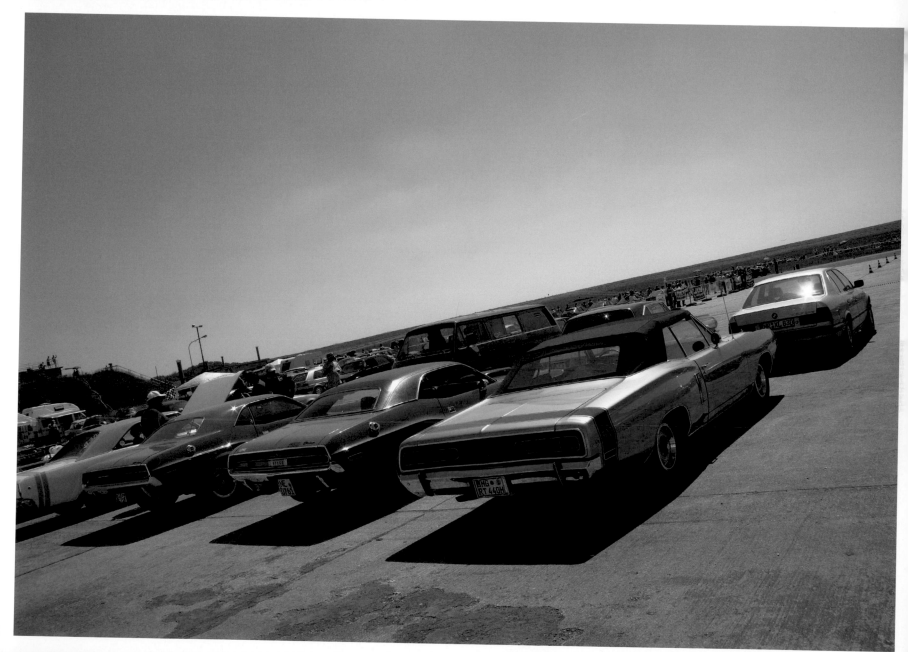

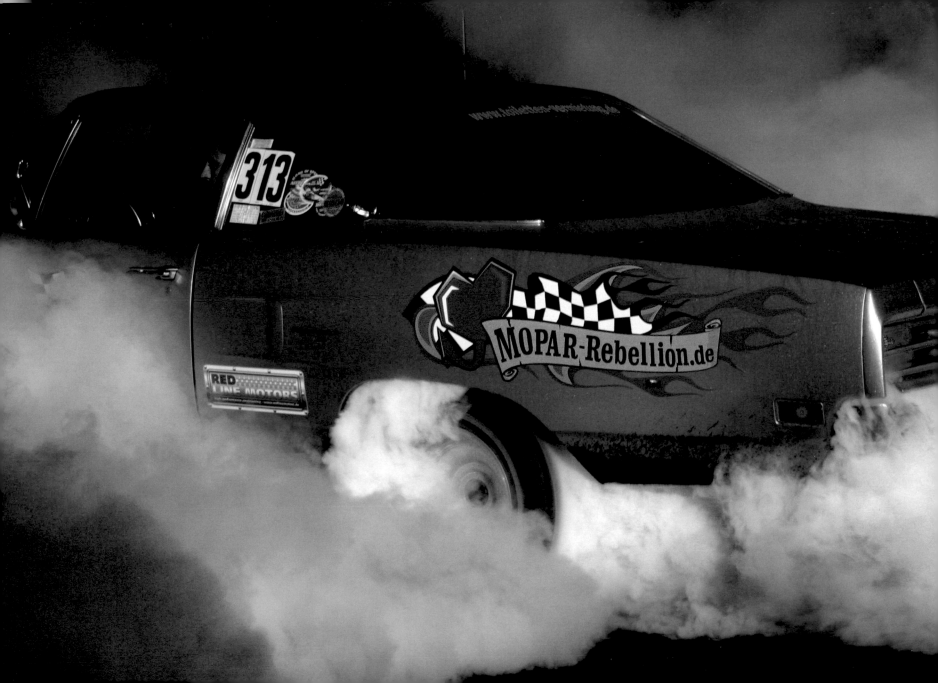

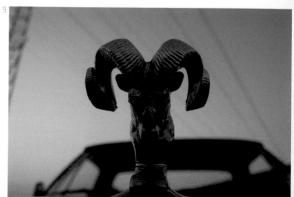

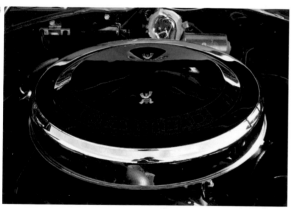

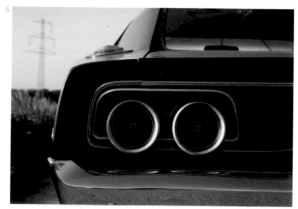

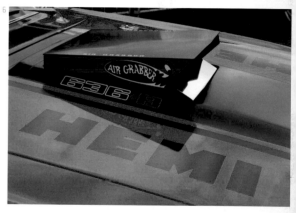

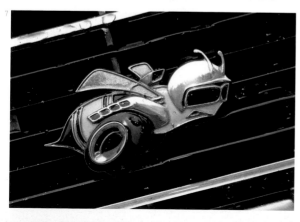

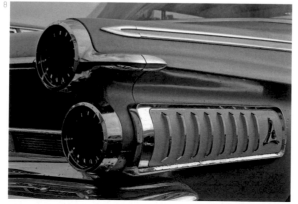

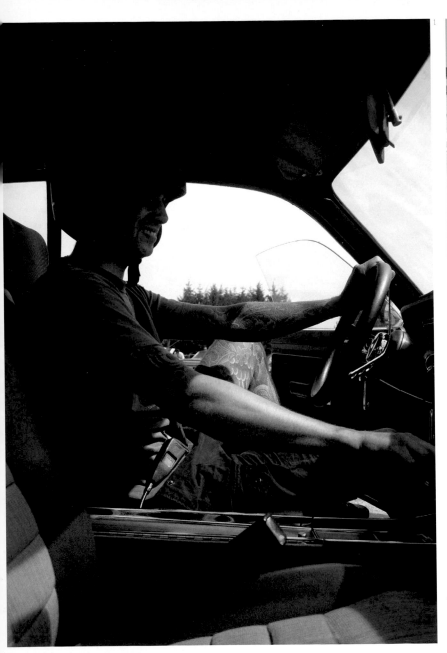

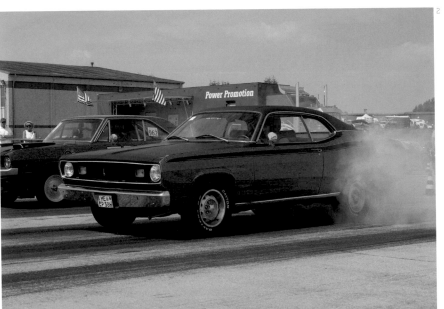

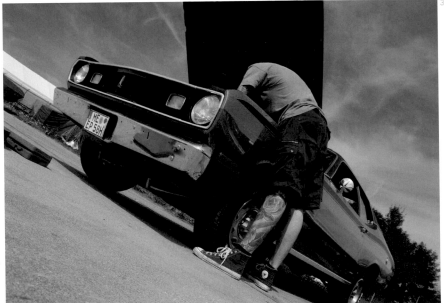

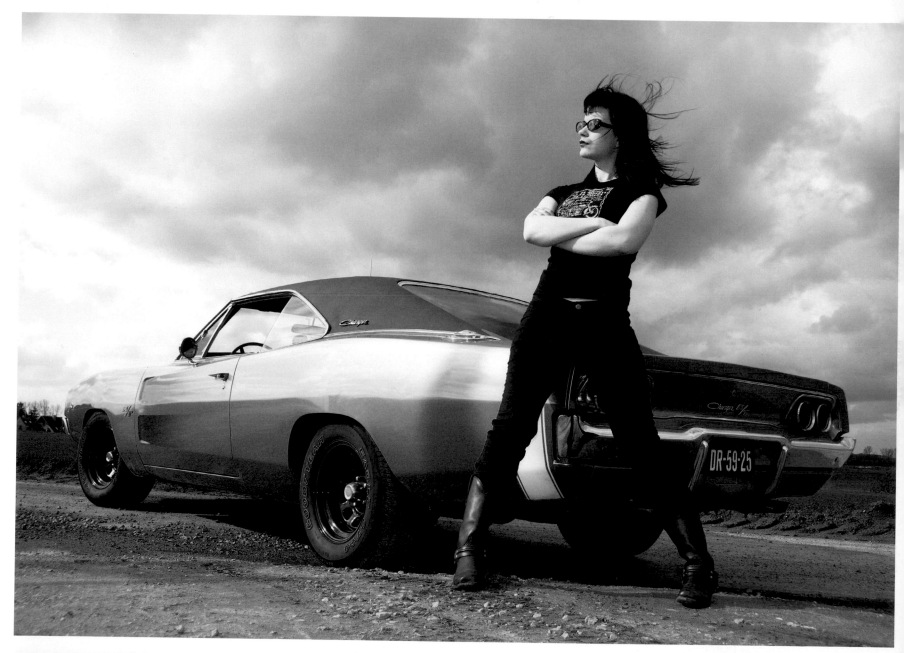

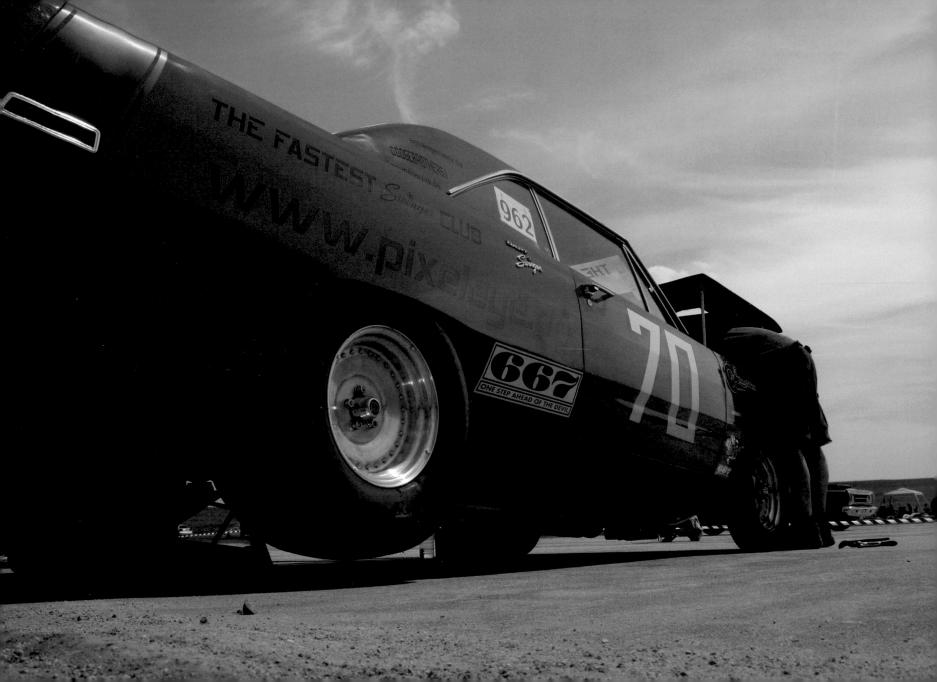

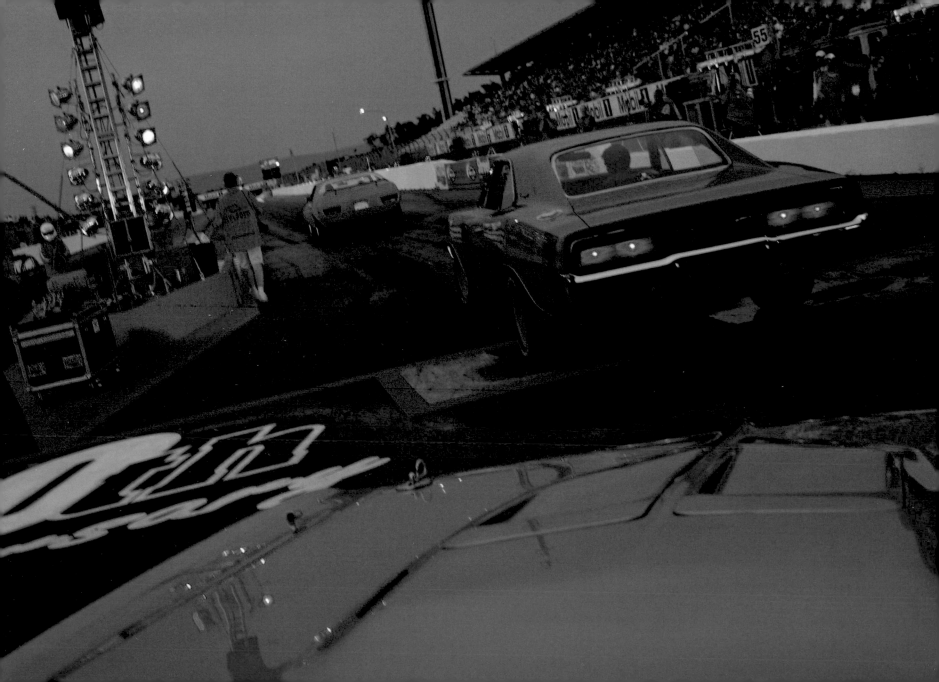

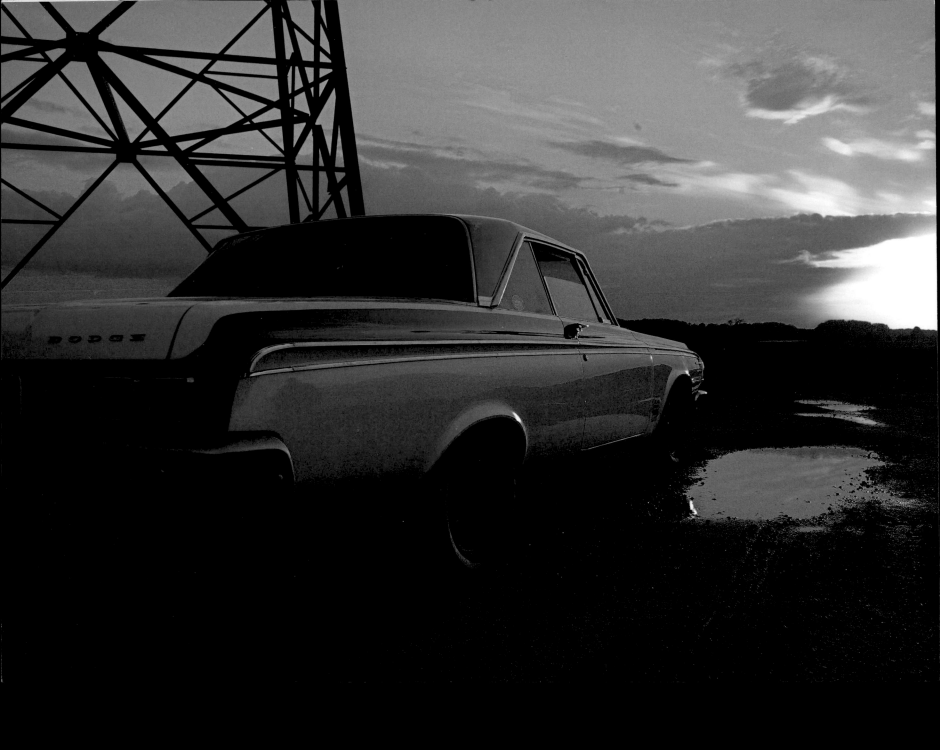

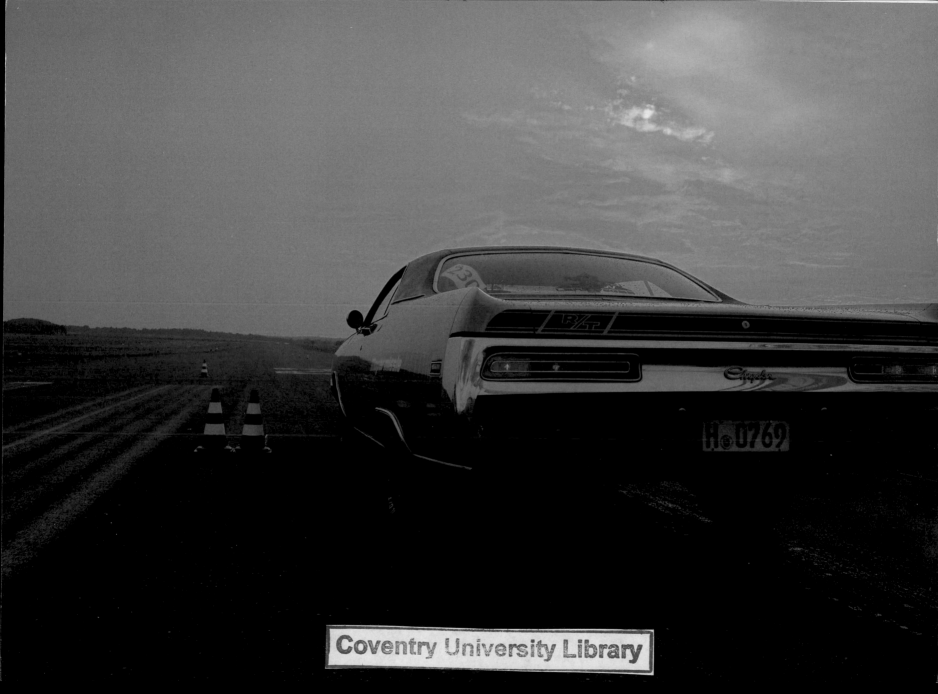

Picture Credits

Hendrick, Rotenburg, Germany 2006
Push off, Rotenburg, Germany 2006
Banana Supergasser, Rotenburg, Germany 2006
Roofer's Toy Promod, NitrolympX
1 Raceready, NitrolympX, Hockenheim, Germany 2006
2 Promod Burnout, NitrolympX, Hockenheim, Germany 2006
3 Peter Wacker & wife, Jay Jay & Zoe, NitrolympX, Hockenheim, Germany 2006
4 Stage, NitrolympX, Hockenheim, Germany 2006
Lucky Lothar, Brandenburg, Germany 2005
Prestage – Mopars at the Strip, Las Vegas, USA 2006
.0 Angel Heart Altered Dragster, Rotenburg, Germany 2006
.1 Kim, Neuss, Germany 2006
.2 Altered Close-Up, Rotenburg, Germany 2006
.3 Angel Heart Burnout, Rotenburg, Germany 2006
.4 Prepare to Race, Chimay, Belgium 2005
.5 Dragster Pilot, Las Vegas, USA 2006
.6 Chevy Pickup, Rotenburg, Germany 2006
.7 Chevrolet 3100, Rotenburg, Germany 2006
.8 1 Trouble Racing Promod, NitrolympX, Hockenheim, Germany 2006
2 Top Fuel Dragster, NitrolympX, Hockenheim, Germany 2005
3 Kath Bros. Promod, NitrolympX, Hockenheim, Germany 2006
4 Golden Nugget Promod, NitrolympX, Hockenheim, Germany 2005
19 1 Inspection, NitrolympX, Hockenheim, Germany 2006
2 Into the Arena, NitrolympX, Hockenheim, Germany 2004
3 Trouble Racing Garage, Basel, Switzerland 2006
4 Golden Nugget Checkin, NitrolympX, Hockenheim, Germany 2004
20 1 Desperado, Las Vegas, USA 2006
2 Mopar Prestage, Las Vegas, USA 2006
3 Mopar staged, Las Vegas, USA 2006
4 Viper Burnout, Las Vegas, USA 2006
21 1 HEMI Shootout, Las Vegas, USA 2006
2 Burnout, Las Vegas, USA 2006
3 Winner Burnout Show, Las Vegas, USA 2006
4 Walco, Las Vegas, USA 2006
22 1 Before the storm, Las Vegas, USA 2006
2 Voodoo HEMI, Las Vegas, USA 2006
3 Burnout Close-Up, Las Vegas, USA 2005
4 Go, Las Vegas, USA 2006
23 Yellow, Chimay, Belgium 2006
24 Dennis & Rick, Bitburg, Germany 2005
25 1 Nova Prestage, Drachten, Holland 2005
2 Dundika Dakota Shooting, NitrolympX, Hockenheim, Germany 2005
3 Freed Racing Supergas Dragster, Bitburg, Germany 2005
26 Michelle, Cologne, Germany 2006
27 Micha, Bitburg, Germany 2006
28 1 Shifter, Bitburg, Germany 2006
2 Mike, Brandenburg, Germany 2005
3 Flames, NitrolympX, Hockenheim, Germany 2004
29 1 We brake for nobody, NitrolympX, Hockenheim, Germany 2005
2 Helmet Pinstriping, Neuss, Germany 2006
3 Stage-In, NitrolympX, Hockenheim, Germany 2006

30 Angel Heart Cockpit, Brandenburg, Germany 2005
31 Green Javelin, Rotenburg, Germany 2005
32 The Bavarian Thunder, Chimay, Belgium 2006
34 Rusty Flames, Chimay, Belgium 2006
35 Race Antz vs. Sleath, Chimay, Belgium 2005
36 Cloud 9, Rotenburg, Germany 2006
37 Into the wide-open, Bitburg, Germany 2006
38 Daan, Bottrop, Germany 2006
39 1 Ride hard, Rotenburg, Germany 2006
2 Straight-on, Bottrop, Germany 2006
40 1 Surf Wagon, Bottrop, Germany 2005
2 Waiting for the race, Bottrop, Germany 2006
3 Flag, Bottrop, Germany 2006
4 Untiteld, Bottrop, Germany 2006
41 Hot Rod Surf, Bottrop, Germany 2005
42 1 Road Devils, Bottrop, Germany 2006
2 Duel, Bottrop, Germany 2006
3 Talkin', Bottrop, Germany 2006
43 1 Setup, Bottrop, Germany 2006
2 Doug, Bottrop, Germany 2006
3 Daan Prestage, Bottrop, Germany 2006
44 Hardcore Rods, Bottrop, Germany 2006
45 Fuck the Police, Bottrop, Germany 2006
46 FTW, Hockenheim, Germany
47 Twenty-Seven, Bottrop, Germany 2006
48 Purple, Bottrop, Germany 2006
49 1 Starting Lane, Bottrop, Germany 2006
2 Intake, Bottrop, Germany 2006
3 Black, Red & white, Bottrop, Germany 2005
50 1 Iron Cross, Rotenburg, Germany 2006
2 K.A.R.S., Essen, Germany 2006
3 Eight-Ball, Bottrop, Germany 2006
51 1 Yoda, Rotenburg, Germany 2005
2 Rat Fink & Moon Eyes, Bottrop, Germany 2006
3 Pennzoil, Bottrop 2006
52 Carrera Hot Rod, Bitburg, Germany 2006
53 1 Shrunkin' Head, NitrolympX, Hockenheim, Germany 2006
2 Hot Rods, Bitburg, Germany 2006
54 On the Roof, Hockenheim, Germany 2006
55 Pinstriping, Basel, Switzerland 2006
56 Fuel Durden, Primerking & Sailorbeast, Rotenburg, Germany 2006
57 1 Lemon Dropped, Rotenburg, Germany 2006
2 Flames Rotenburg, Germany 2006
3 Street Rod, Lommeln, Holland 2005
58 Hot Rod Heaven, Basel, Switzerland 2006
59 Back in Black, Basel, Switzerland 2006
60 Black Night, Basel, Switzerland 2006
61 Jay Jay 666, Basel, Switzerland 2006
62 Hot Rod Kai, Rotenburg, Germany 2006
63 1 Race Antz, NitrolympX, Hockenheim, Germany 2004
2 Maratta by Mr. Z, Much, Germany 2006
3 Jay Jay's Garage, Basel, Germany 2006
4 Hot Rod Kai Close-Up, Rotenburg, Germany 2006
64 Kath Bros., Drachten, Holland 2005

Credits

Speed Kings is dedicated to all the Hot Rodders, Drag Racers and High-Octane Burners from all around the globe who drive their vehicles in style and with passion! Ride on.

✳ ✳ ✳

Thanks to all these great people, friends, teams for their support:
My girlfriend Anne, my daughter Aimée, Mom & Dad, Ralf Becker (Chromjuwelen.com), Zoe Scarlett, Markus Münch aka "The lonesome Dragstripper" himself (Dragstripper.de), Micha Vogt & Race Antz Team, Stefan Ruf (Dakota), Peer/Claus/Frank/Moritz/Harry (Dodgebrothers.de), Michael Kronenberg (Big7.net), Marc Wnuck (12ender.de), German Drag Racing Board/Dragracing.de (Torsten & Jürgen Kath), Tog & Crew from Eurodragster.com, Ulle/Mitch/Helge (Motoraver Magazine), Dennis Kieselhorst/Andreas "Kalunki" Dierking/Jens Buchholtz (German Dragracer Magazine), Darius Klapp/Armin Kußler (Street Magazine), All at Mopar-Forum.de, Thorsten "Skorpion" Appel & Julia Schoedsack from Likkedeeler Racing, Dirk Peiler & Jensen (Mopar Rebellion), Phillipp Wohleben (AMS TV), Theo Terror (Medienpirat), Tim Schmuck (TST-Company), David Vicente, Jay Jay (The Hollywoodz), Laurent Bagnard (PowerGlide Magazine), Timsche/KTS, Silke Beer/Hugo/Garry/Heiko & Team (1on1 Motorsports), Tim & NG Drag Racing, Maren Siede, Christian Schaarschmidt for building the book dummies, Nic Heimbuch, Daniel Harrington & Pascal Jeschke (Encore Magazine), Jan-Christopher Sierks (Prestige Cars), Michael Perresch & Daan van Ravenswaay (Intake Magazine), Tanja "Strawberry Bombshell", Kreuzritter, Oliver "Mr. Z." Zeilinger, Uli "Chrome sucks" Kegelmann, El Cheapo, Andre & Annett Müller, Lothar "Lucky" Feidt, Dennis Freed & Rick Castille (Freed Racing), Lutz/Julian Rose & Angelheart Dragracing, Hot Rod Ove, Michi Weber, Michael Mikuscheit, Hot Rod Kai, Oliver Zinn/Moparshop, Tony Brandes, Thom Piston (Smokin' Shutdown), Boris "Doc" Baur, Peter Wacker/Roofer's Toy, Guido Uhlir, Marcus Hilt (Trouble Racing), Gittli & Peter Schöfer Racing, Henning Blume, All Harley Drags, Matte & all at Matte Racing Team, Reinhard Garbers & Tina, Bernd Kaltenbach & Pentastar Dragracing, Udo "Granata" Fink, Ralf Schellhorn, Andrea Kloss (DragRacingHistory.de) Jens "Zippel" Zimmermann (Banana Too Racing), Benni Voss, Rico Anthes/Christine Calwer & NitrolympX (Dragster.de), Ian King (King Racing), Hankabilly, Mike Poser & Stars & Stripes Dragracing, Andy Widder (Dynamite Magazine), Tom Zellner & BugWahn Dragracing, Walter Hanusch (Roadrunner Drag Race Team), Jens Böhmig (Richarzzz), Peter "Pepe" Jürgens, Timo (Werner Hambermann Racing), all the guys I do not know personally but are in the book and everybody I may have forgotten!

The Pin-Ups: Penny, Samantha, Zoe, Michelle, Sweetness, Michaela, Rojda, Dundika, Kim, Sari, SpookyMind, Yvönne.

Extra special thanks to and all magazines, publishers, fans, internet portals who supported me throughout the years! You rock! Thank you all!

✳ ✳ ✳

Drop by at: www.speedkings-book.com
Dirk Behlau on the web: www.pixeleye.de, www.hotrodhell.de

Dirk Behlau

Dirk Behlau, born in 1971, is a professional designer and photographer from Germany. Although he works with a broad range of topics and media for international clients and magazines, Dirk's passion is photographing old-school Hot Rods, Dragsters, retro styled Pin-Ups and protagonists. In addition to shooting American automobiles from the 1930s to 70s, he can often be found at drag racing events authentically documenting the adrenalin-fuelled atmosphere on and alongside the track with his camera.

Photos by Lioba Schneider

Speed Kings

Racing Photography by Dirk Behlau

Edited by Robert Klanten and Hendrik Hellige
Layout: Hendrik Hellige and Sabrina Grill for dgv
Production management: Martin Bretschneider for dgv
Printed by Graphicom Srl., Italy

Published by Die Gestalten Verlag, Berlin 2007
ISBN: 978-3-89955-197-6

Bibliographic information published by the Deutsche National-
bibliothek. The Deutsche Nationalbibliothek lists this publication
in the Deutsche Nationalbibliografie; detailed bibliographic data is
available on the Internet at http://dnb.d-nb.de.

None of the content in this book was published in exchange for pay-
ment by commercial parties or designers; dgv selected all included
work based solely on its artistic merit.

This book was printed according to internationally accepted stan-
dards for environmental protection.

For more information please check: www.die-gestalten.de
Respect copyright, encourage creativity!